THE
FANTASY TATTOO
SOURCEBOOK

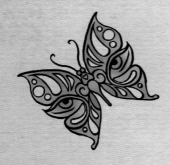

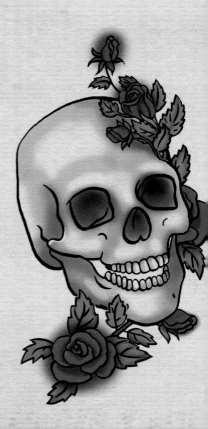

THIS IS A CARLTON BOOK

Published in 2011 by Carlton Books Limited
20 Mortimer Street
London W1T 3JW

10 9 8 7 6 5 4 3 2 1

A CIP catalogue record for this book is available from the British Library.

ISBN 978 1 84732 984 4

Printed in China

Senior Executive Editor: Lisa Dyer
Managing Art Editor: Lucy Coley
Design: A&E
Picture Research: Ben White
Production: Kate Pimm

THE FANTASY TATTOO SOURCEBOOK

OVER 500 IMAGES FOR BODY DECORATION

CARLTON

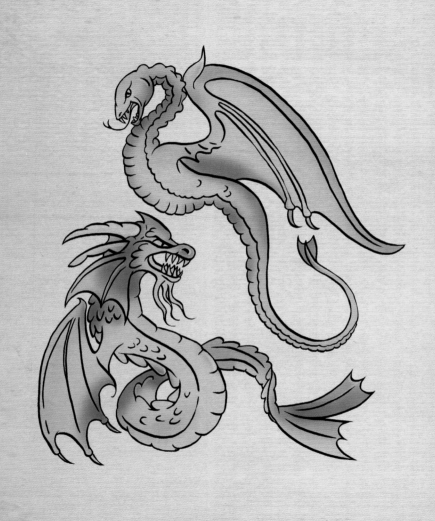

CONTENTS

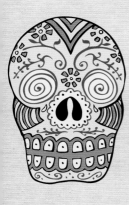

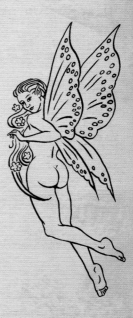

INTRODUCTION

Marking the body is the ultimate form of self-expression and tattoos – whether temporary or permanent – are a relatively inexpensive and creative way to show your individuality. Tattoos are more than just images and symbols, they are a way to enhance the body with beautiful and imaginative artwork. In this collection of 500 tattoos, the genre of fantasy art is explored, from the magical and supernatural to ancient myths and legends as well as monsters, beasts and fanciful creatures such as dragons, unicorns, fairies, witches and wizards. In addition a host of heavenly and hellish beings are depicted – angels and cherubs along with skeletons and skulls, devils and demons.

Evolving from classical Greek and Roman mythology, as well as the legends and folklore of ancient civilizations and other sacred traditions of both religious and spiritual natures, this form of art springs from the imagination more than any other. The urge to re-make nature and what we see on earth into the fantastical and to delve into the dream world seems to be part of the human desire to exercise the subconscious.

Many people cite the artist Hieronymous Bosch as the father of fantasy, and he created hallucinatory masterpieces filled with burning landscapes, strange animals and insects and depraved humans, visions that explored both the dark side of human nature and taboo subjects. Other connections to fantasy art include the Pre-Raphaelite artists,

who developed a painting style that drew inspiration from poetry and contained deeply symbolic imagery, and illustrations from children's fiction such as that by Arthur Rackman, who gave potency to enchanted worlds with his dark, haunting sketches. The Victorian era was also noted for the prevalence of "fairy paintings", from the sinister fairies of the painter Richard Dadd and John Anster Fitzgerald to the Cottingley Fairies photographs in 1917. Science fiction, particularly from the 1950s to the 1970s, also gave rise to fantasy art, such as in the "sword and sorcery" stories by Fritz Leiber and novels by JRR Tolkein who created the world of Middle Earth. From a rich and vivid history, the world of fantasy art contains many sub-genres, such as horror and the paranormal. Because artists can explore the unexplainable and give form to their deepest fears and desires, fantasy art continues to be extremely popular today.

Whether you choose to copy the designs here for your tattoo or use them as inspiration to create your own version, feel free to scan, trace or adapt one or different parts of several tattoos to create your own designs. Before committing to a permanent tattoo, you may want to draw the design onto your skin using body paints or pens, airbrush inks or henna, and advice on these various approaches is given on page 250. This will give you the opportunity to explore various colours, placements and arrangements, as well as live with the tattoo for awhile, before you make a final decision.

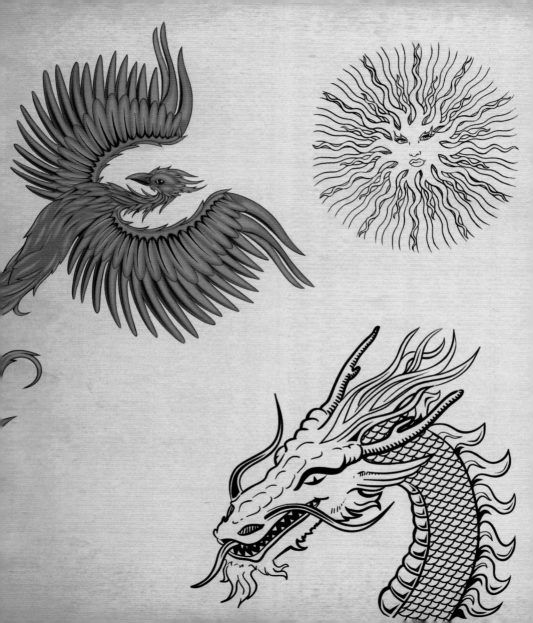

MYTHS AND LEGENDS

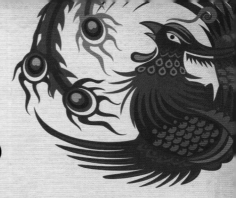

An enduring fascination for classical mythology – from Greek and Roman to Nordic and Egyptian – appears again and again in tattoo culture, as do folklore, stories and legends. Heroes, deities and monsters provide a moral compass and often symbolize virtues or vices such as justice, love, strength, beauty and truth, or fear, jealousy, temptation and disaster. Many people who choose to get such a tattoo see a similarity between a mythological character and themselves or feel that the character's story connects with their own life.

Along with images of gods and goddesses, designs for half-human beasts, such as the minotaur and centaur, depict the animalistic nature of man, while many sea creatures, such as sirens and mermaids, serve to tempt and the monsters the Hydra, Scylla and Kraken endanger lives, particularly sailors. Other images include the winged horse Pegasus, who symbolizes speed, strength and artistic inspiration, the unicorn, a healer of illness, and the phoenix and bennu bird, which symbolize rebirth and immortality.

In Chinese culture, dragons are seen as protectors of life, fertility and good fortune, and these are mostly snake-like with brightly coloured scales. Western dragons, on the other hand, tend to be reptilian fire-breathing beings with bat-like wings that destroy villages and guard treasure. A huge variation are included here.

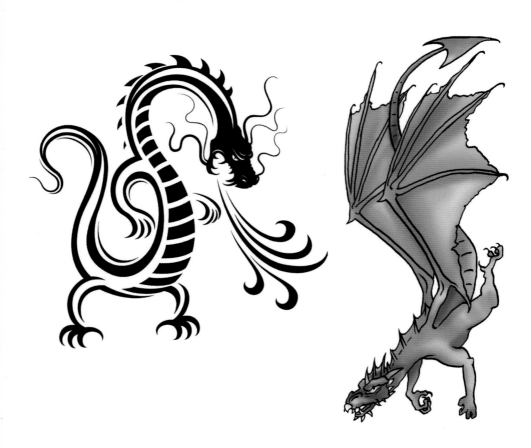

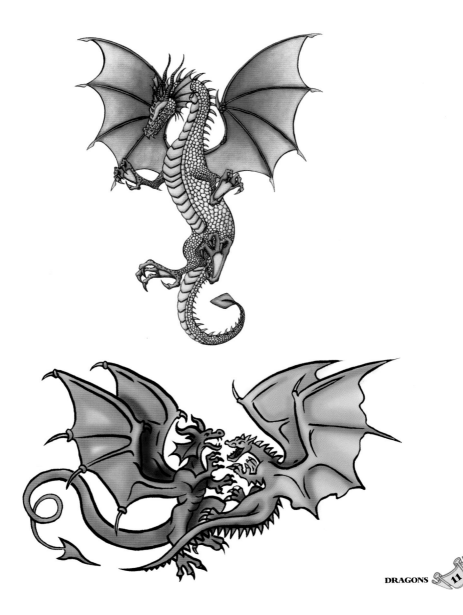

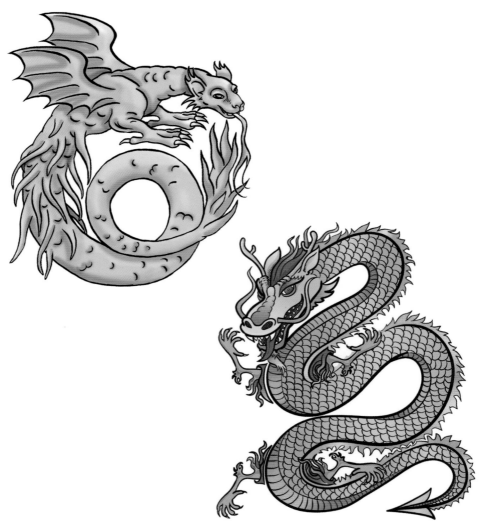

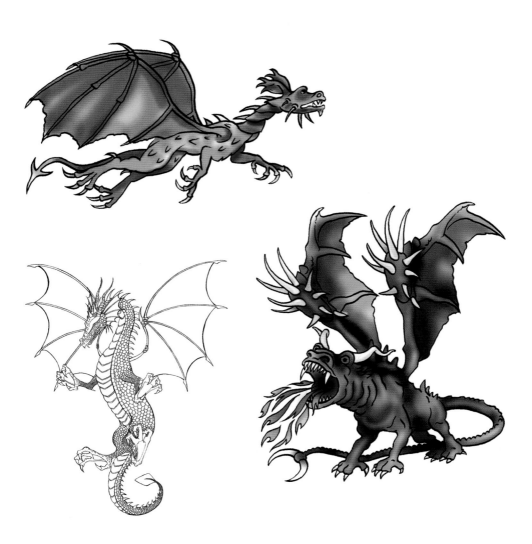

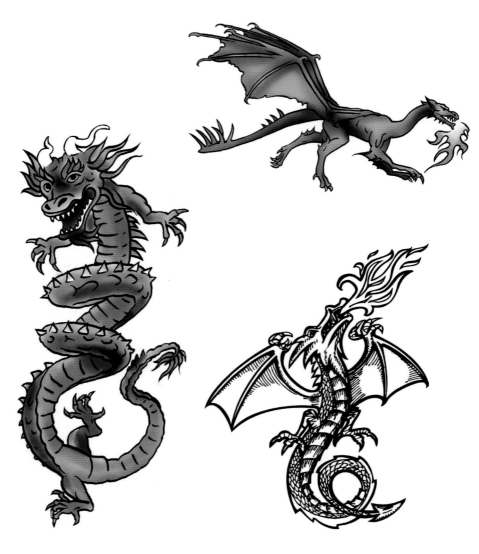

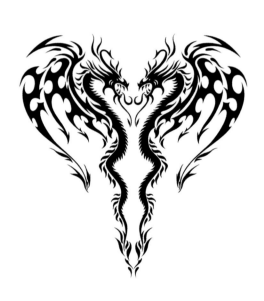

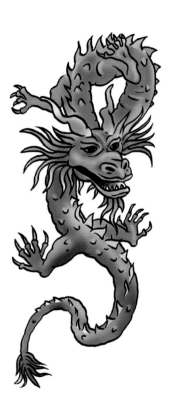

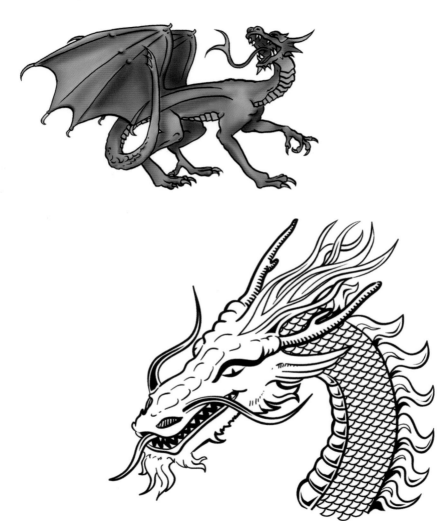

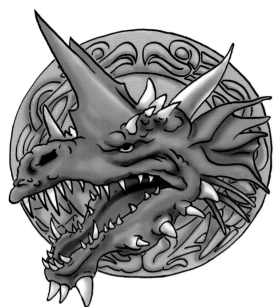

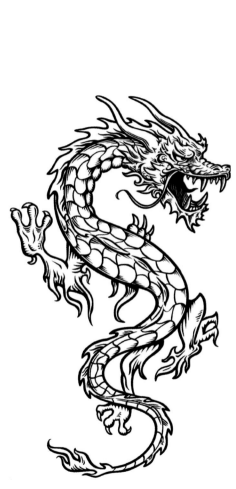

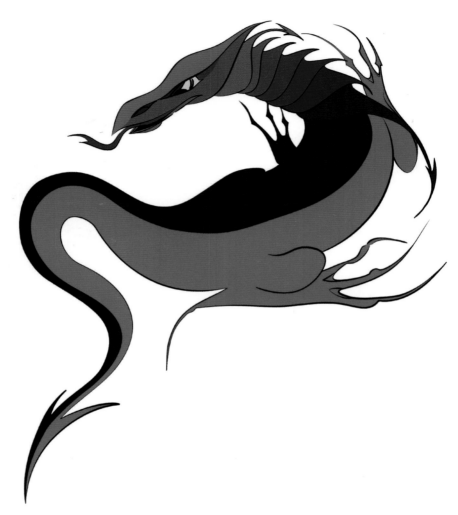

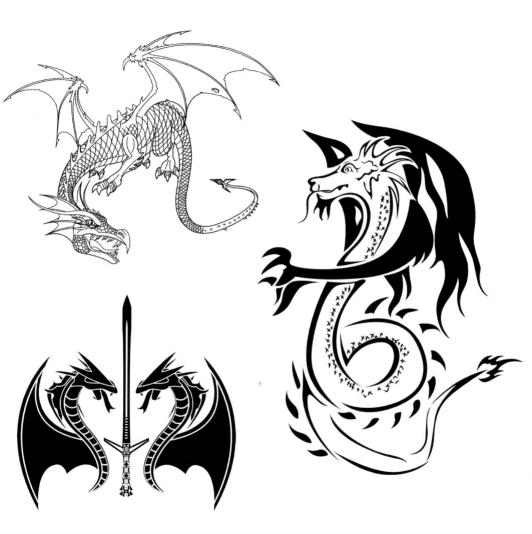

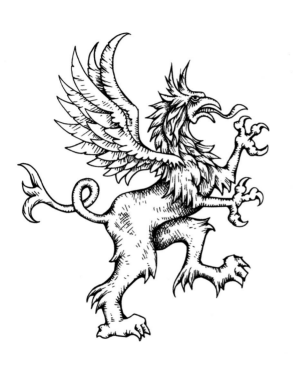

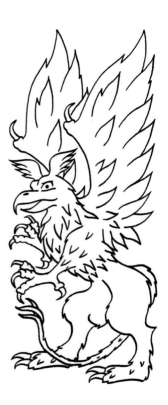

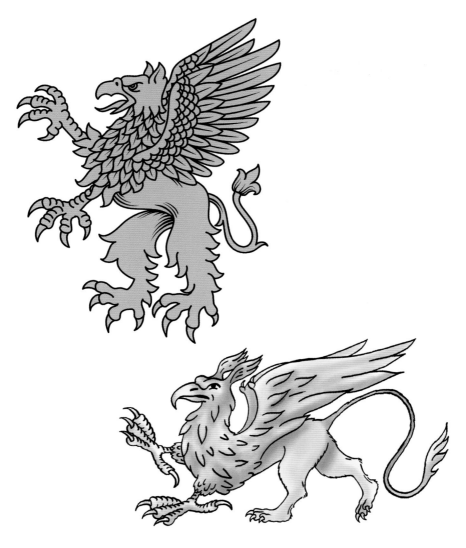

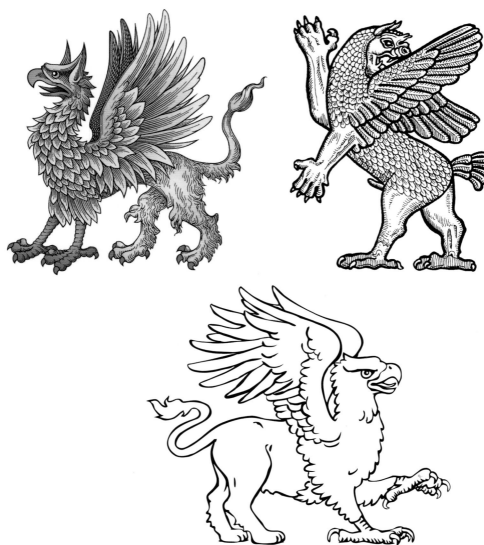

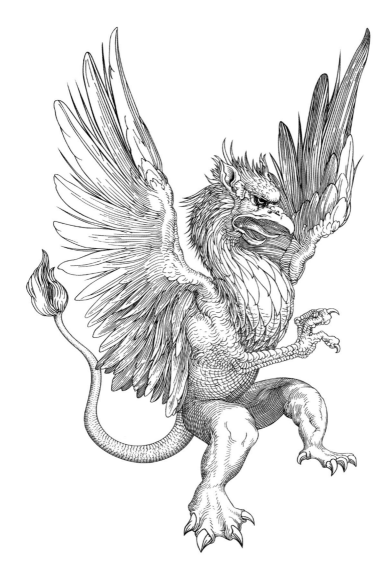

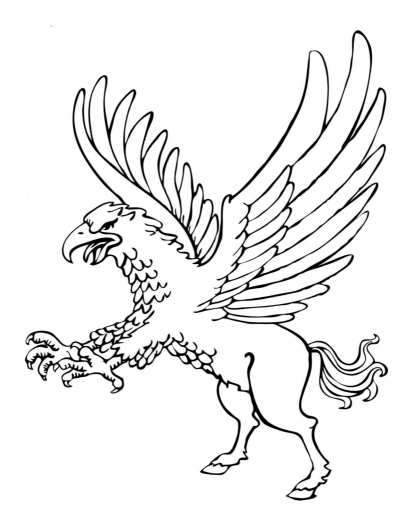

 HIPPOGRIFF

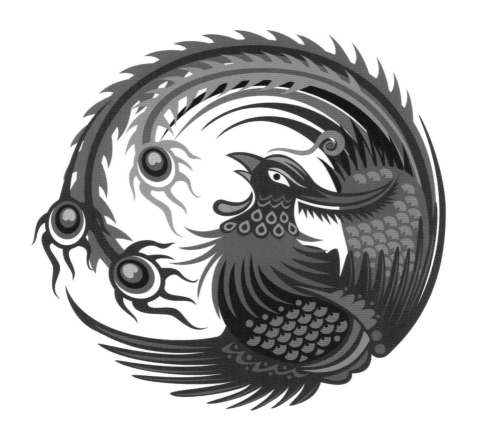

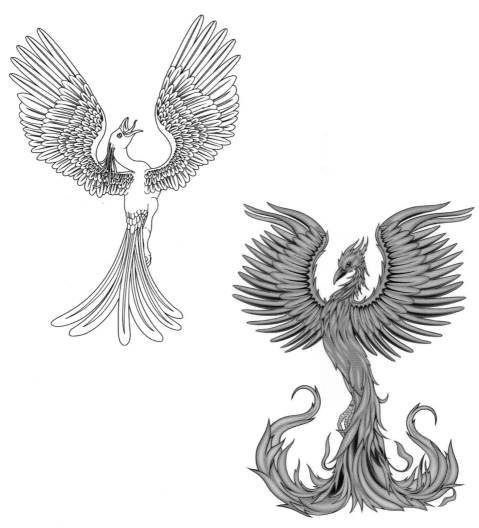

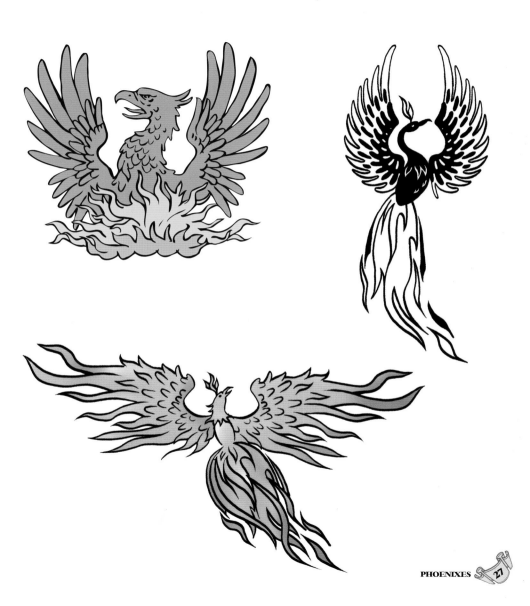

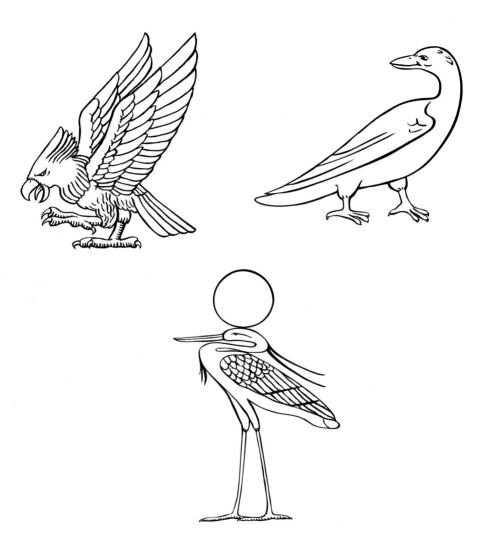

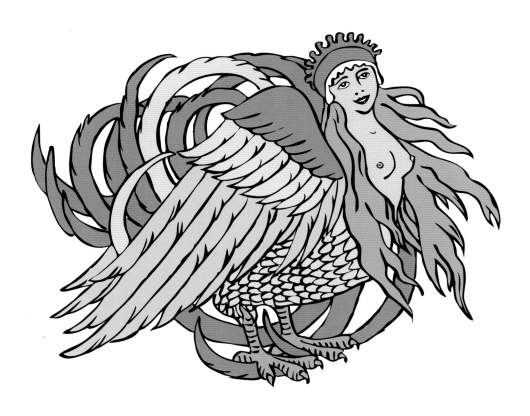

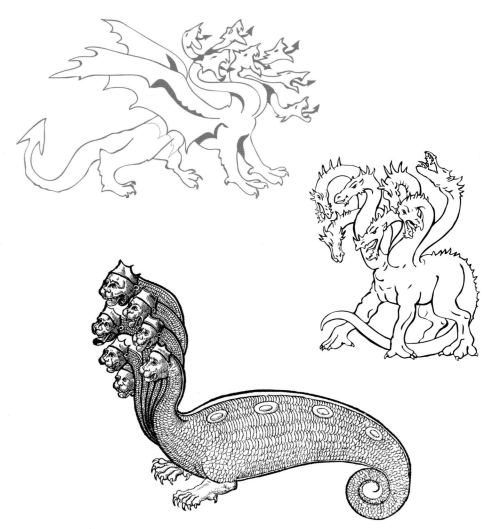

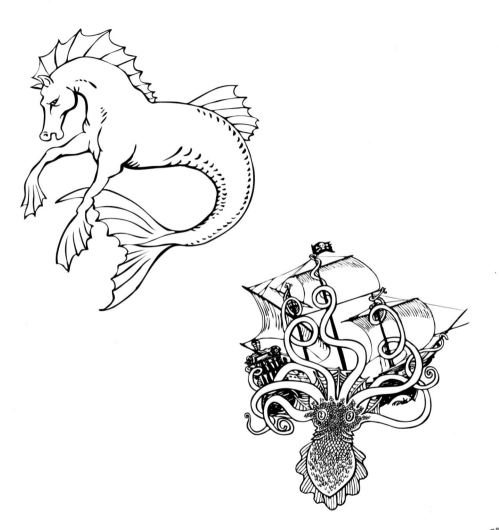

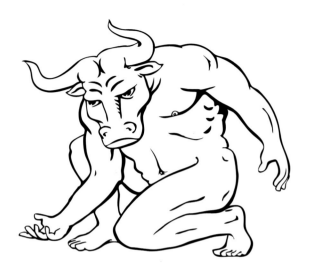

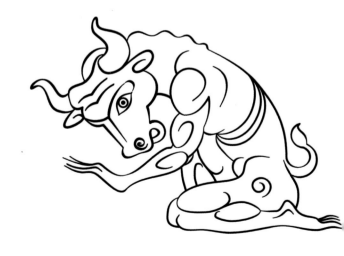

 MINOTAURS

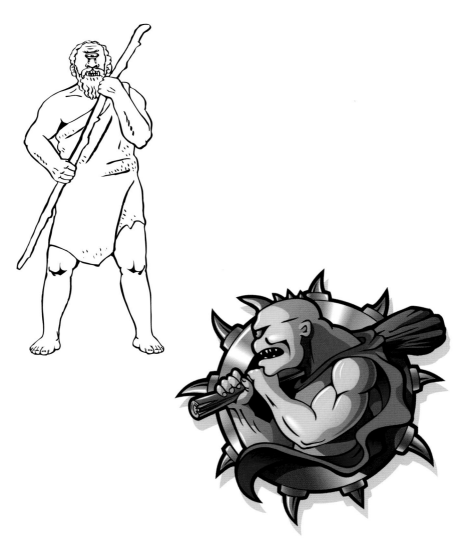

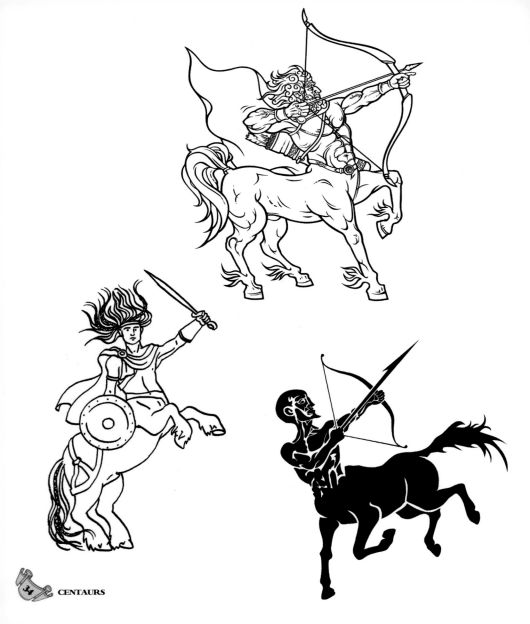

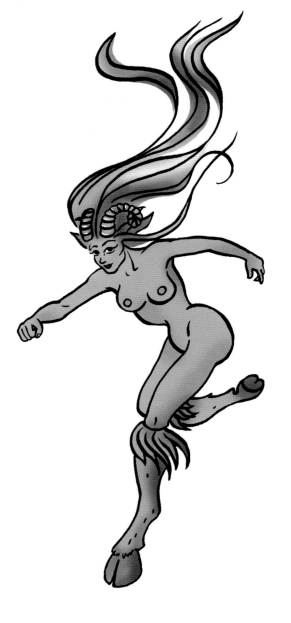

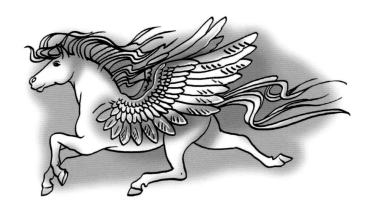

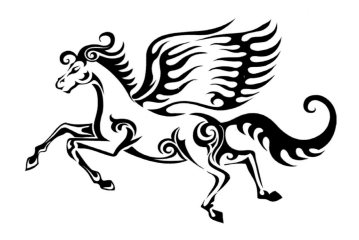

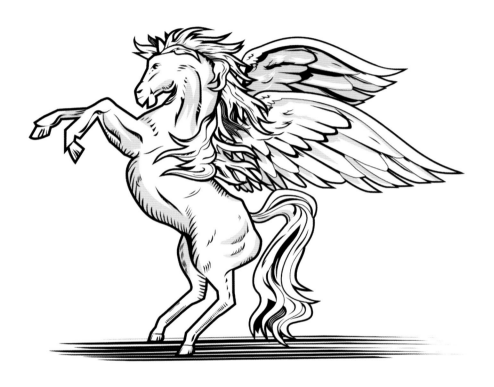

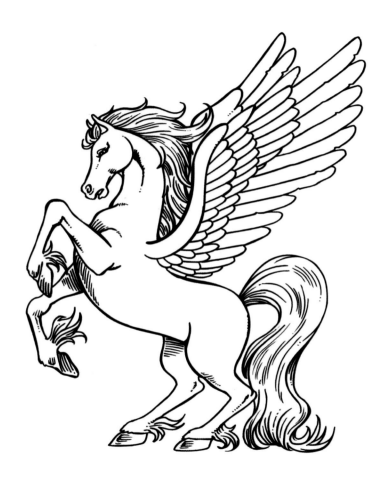

 PEGASUS

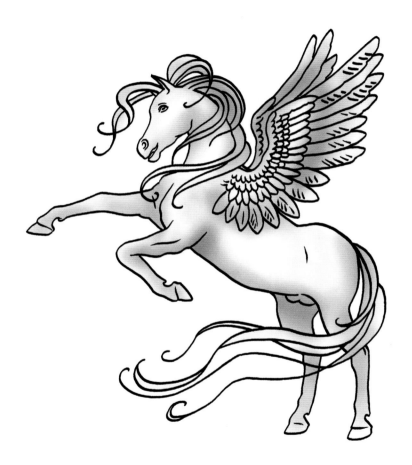

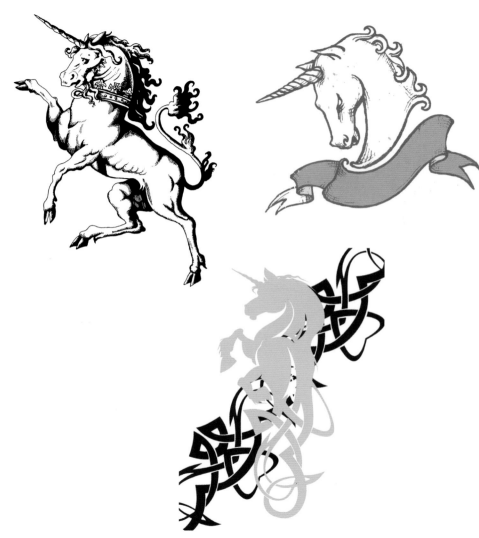

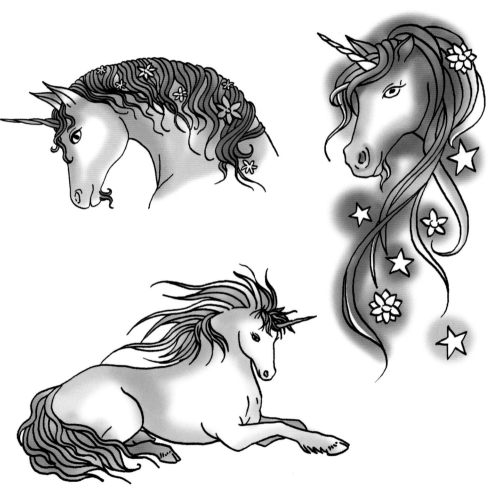

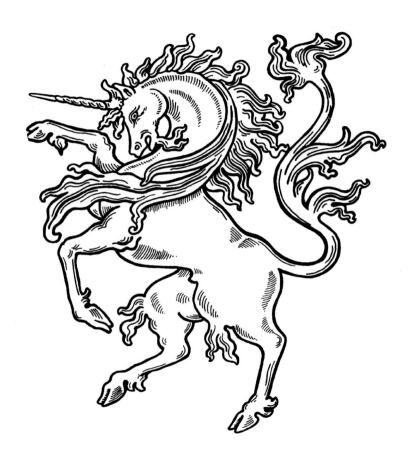

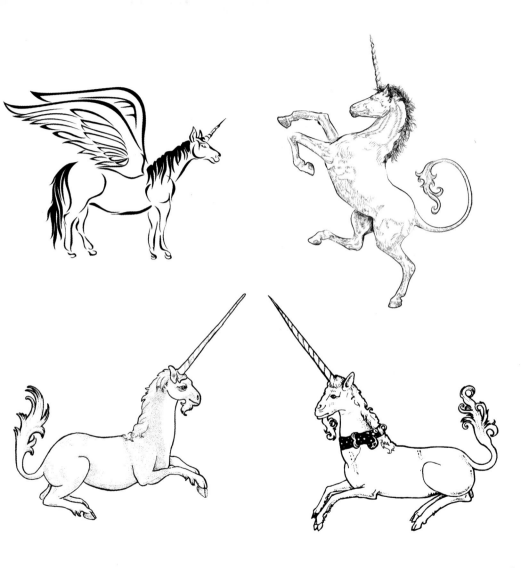

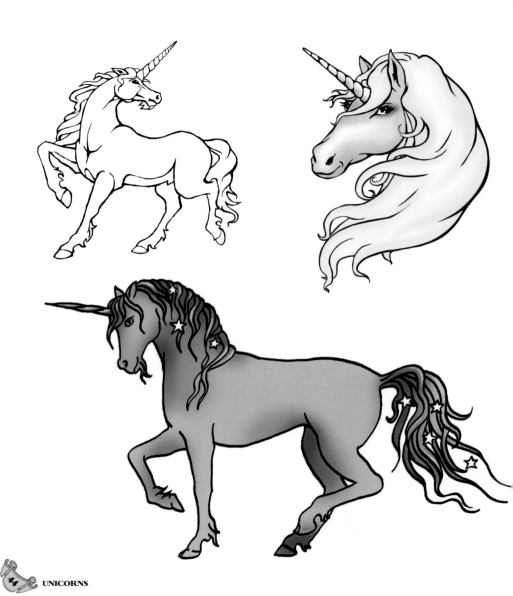

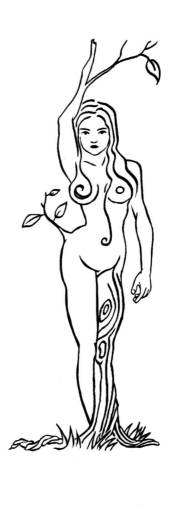

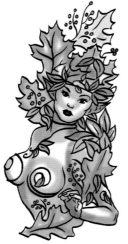

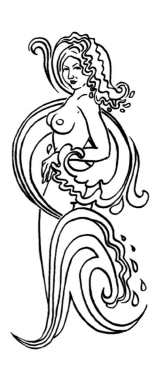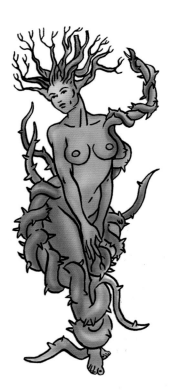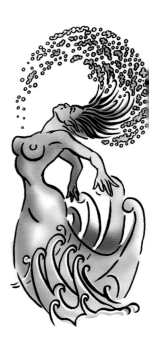

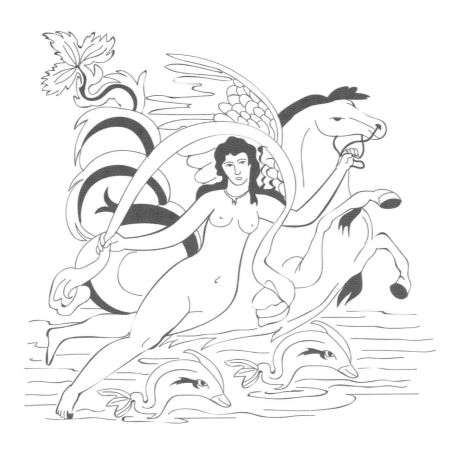

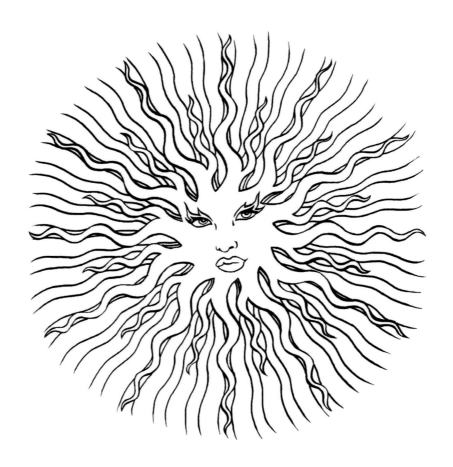

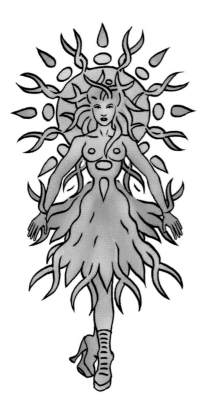

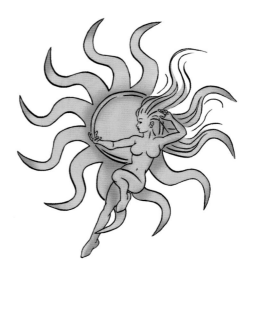

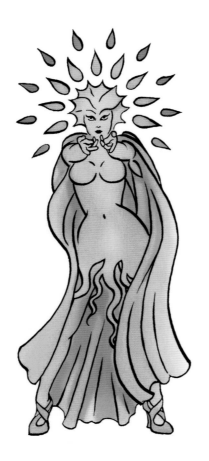

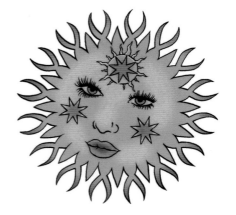

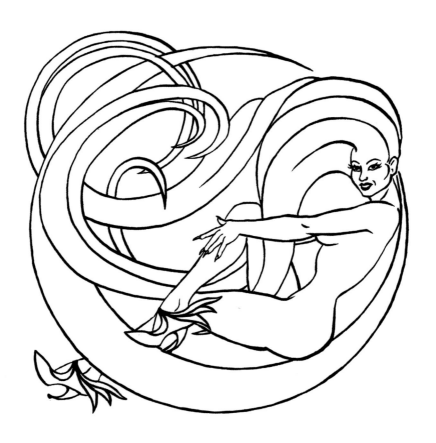

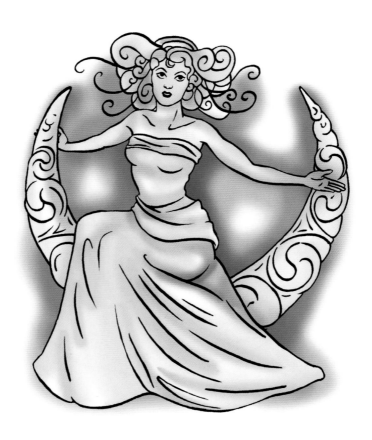

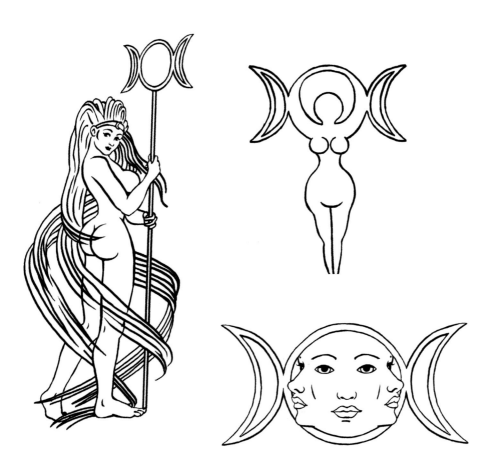

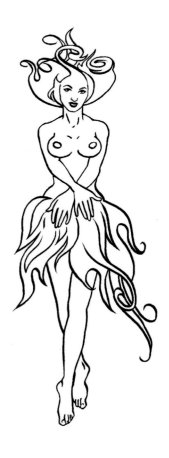

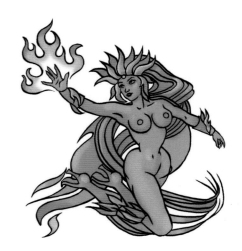

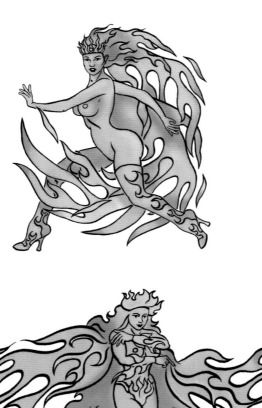

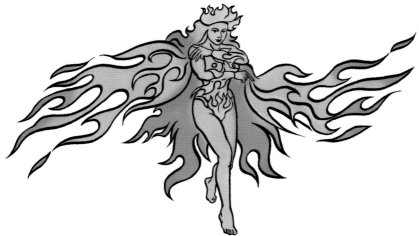

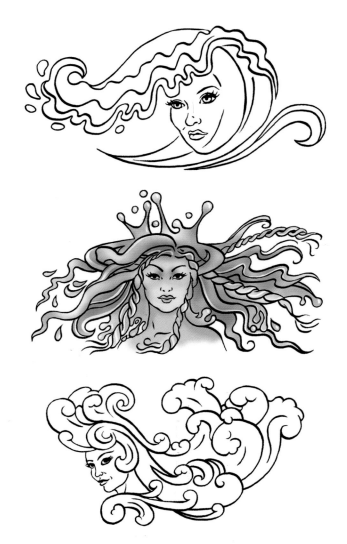

WATER GODDESSES

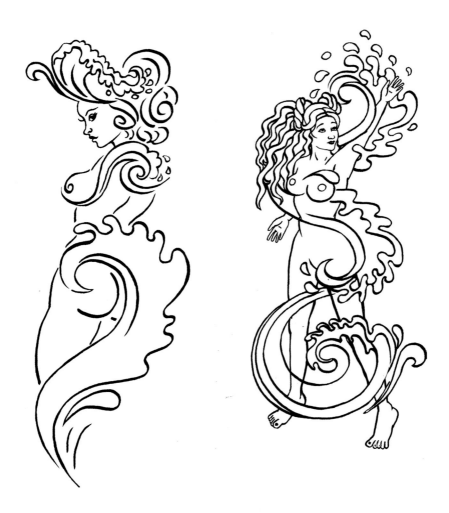

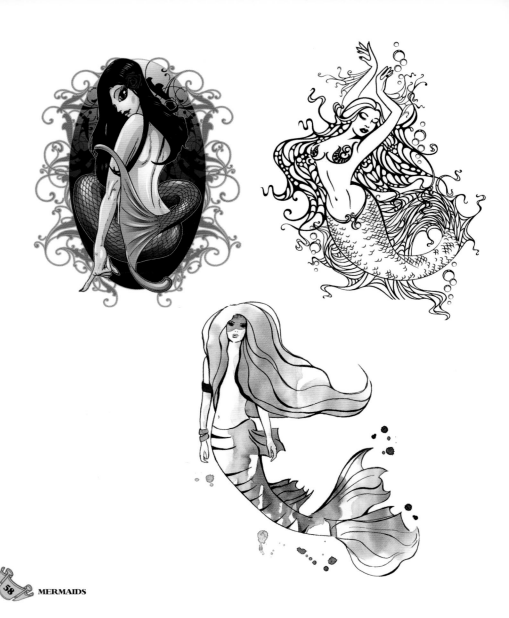

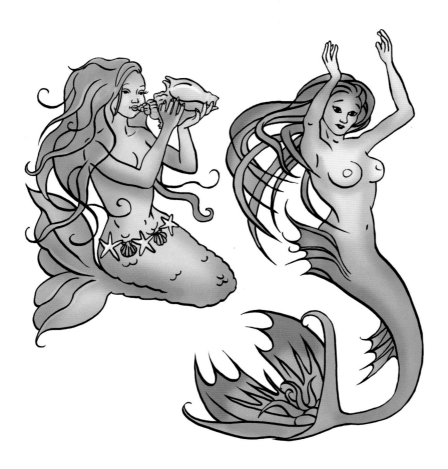

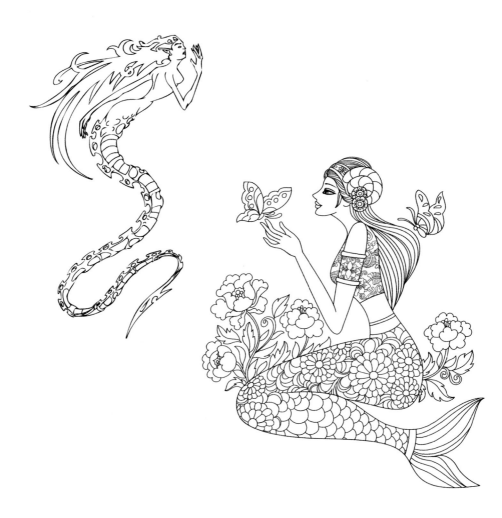

 MERMAIDS

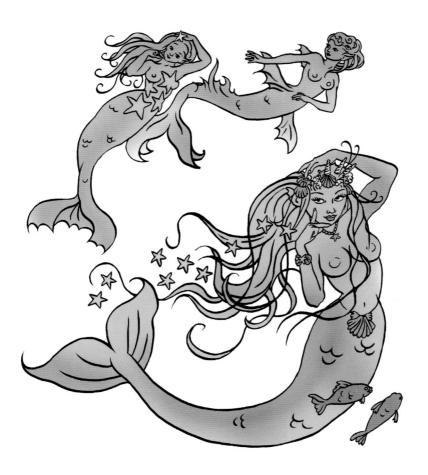

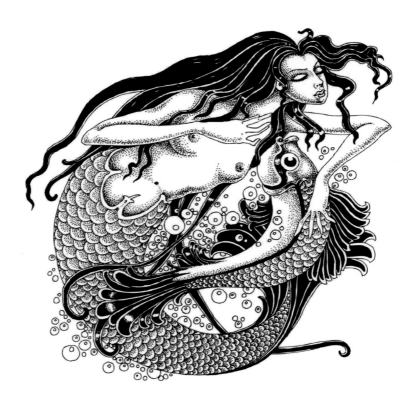

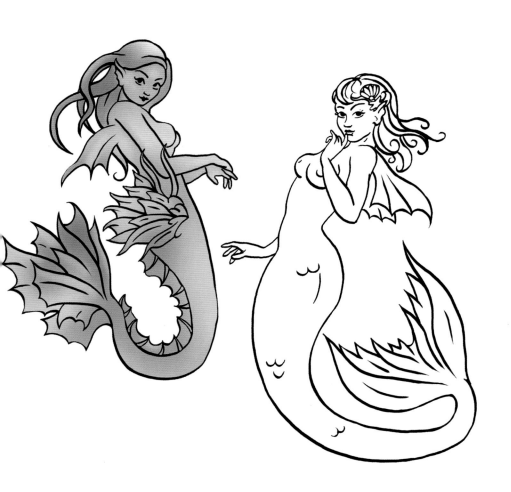

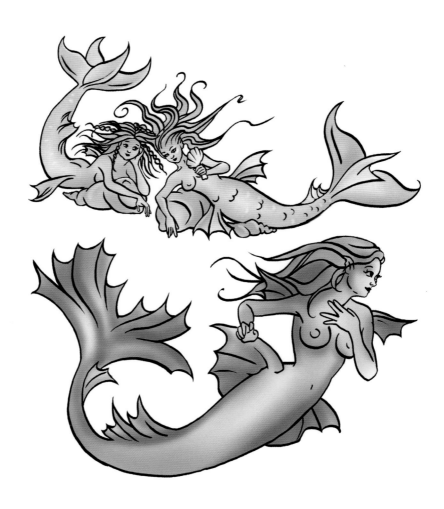

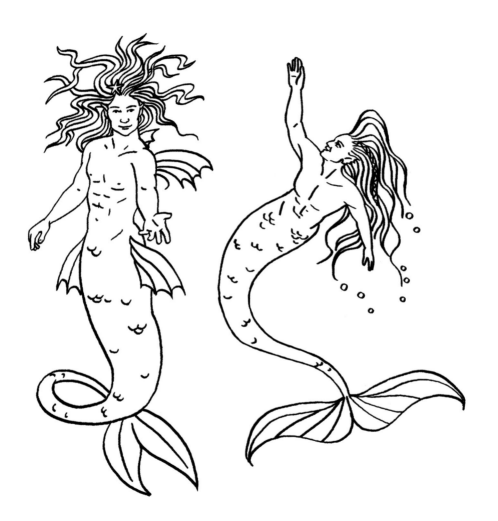

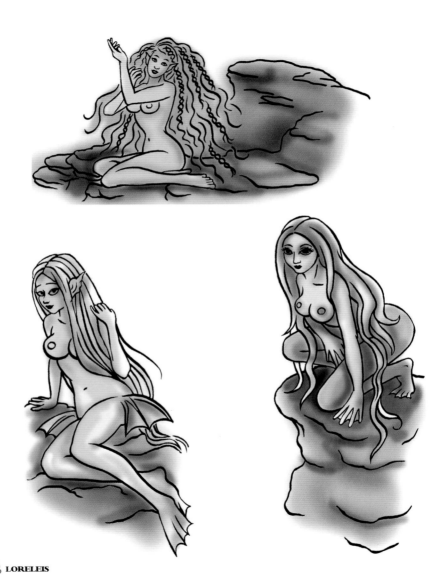

LORELEIS

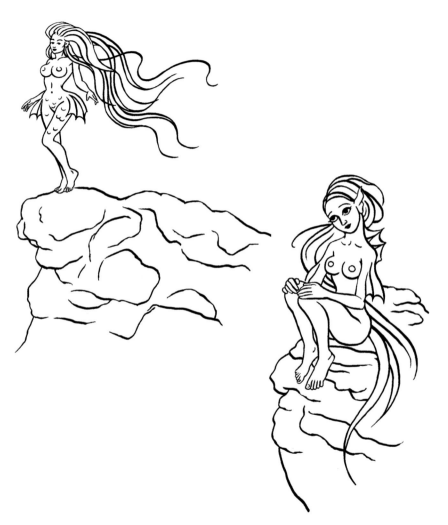

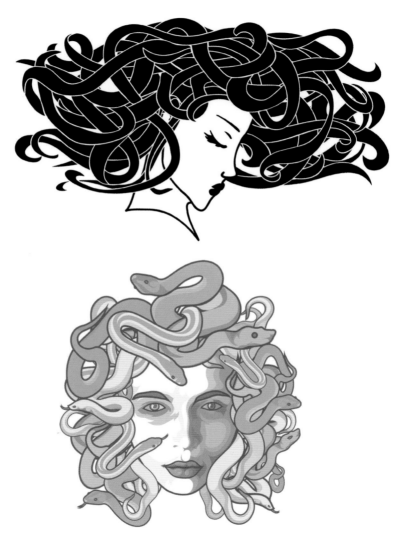

GORGONS

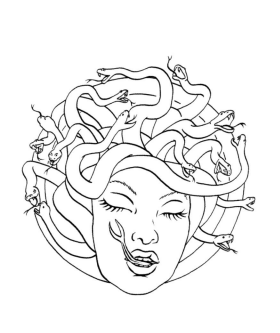

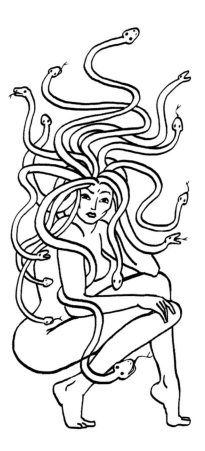

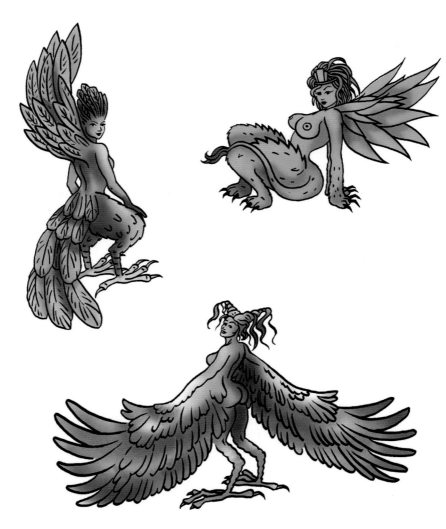

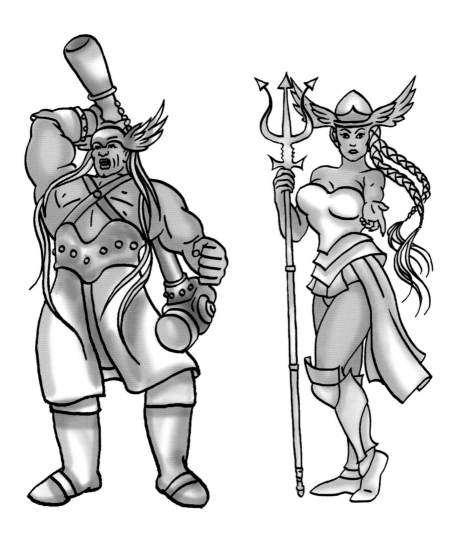

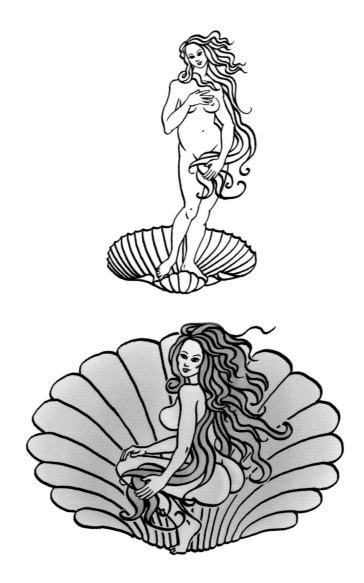

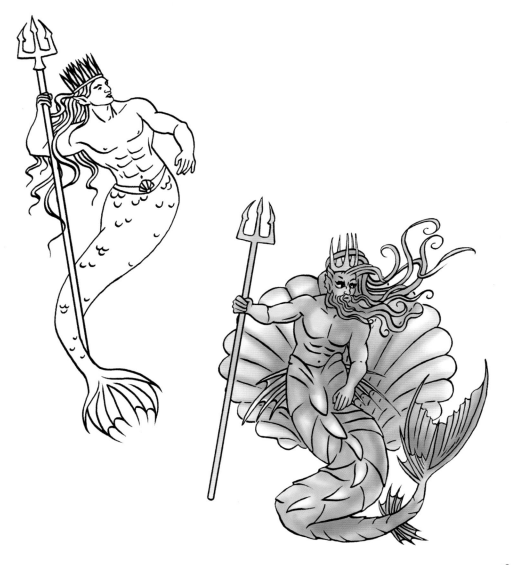

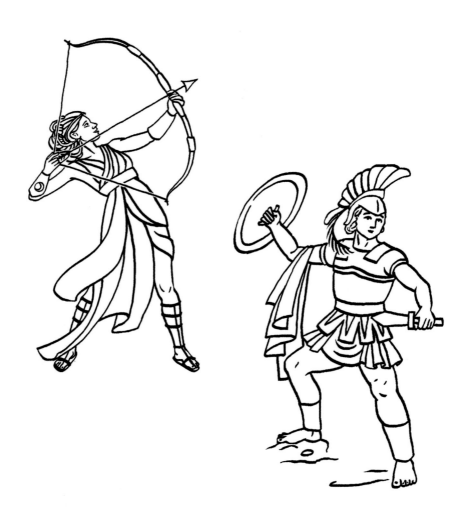

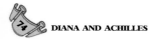 **DIANA AND ACHILLES**

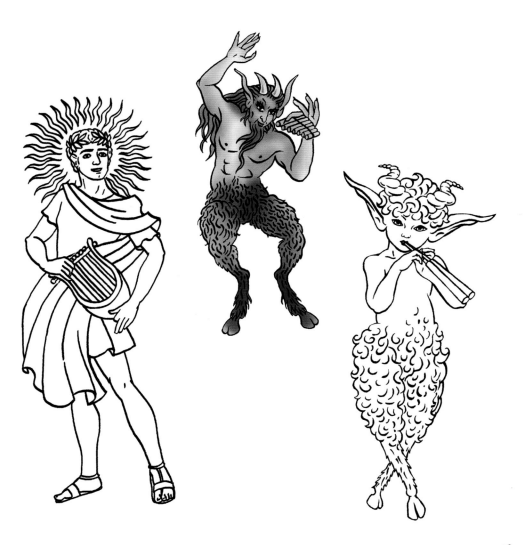

MAGICAL CREATURES

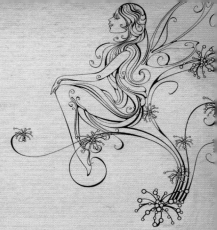

Fairies, pixies, leprechauns, trolls, goblins and other magical creatures that possess supernatural powers are the subjects of this fantasy-art chapter. Often these types of tattoo designs are chosen by people who want to guard themselves against evil or bad fortune, or who are fascinated by the mystical or spiritual world.

Fairies, one of the most popular types of tattoos for women, are often depicted as young, beautiful, winged and mischievous. They are associated with destiny and fate, and can be either gift-giving or malicious, empowering or destructive; in popular culture they are believed to help protect against evil forces and intervene in injustices. Although the motif is most often associated with childhood and innocence, older legends exist of fairies that are human-sized and dead. Fairy tattoo designs can be extremely detailed and ornate and often include other images from the natural world, such as flowers, toadstools, birds or butterflies.

Witches, wizards, black cats, toads, pentagrams and other associated magic symbols can make very effective designs, particularly for those interested in the Occult, paganism, and Wicca, or who are simply keen to wear a tattoo that serves as a talisman or charm.

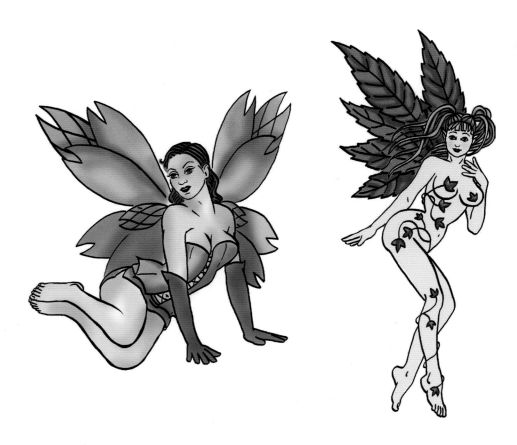

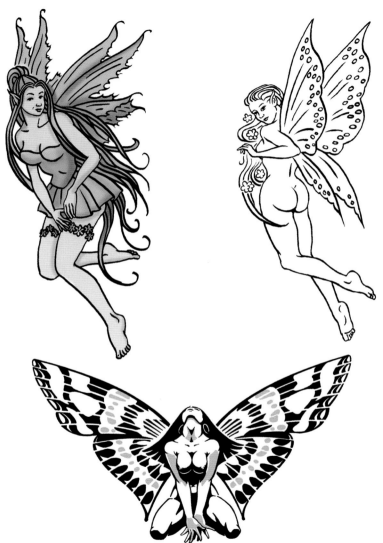

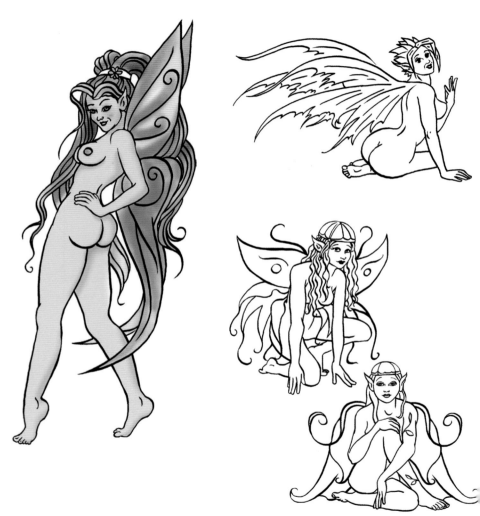

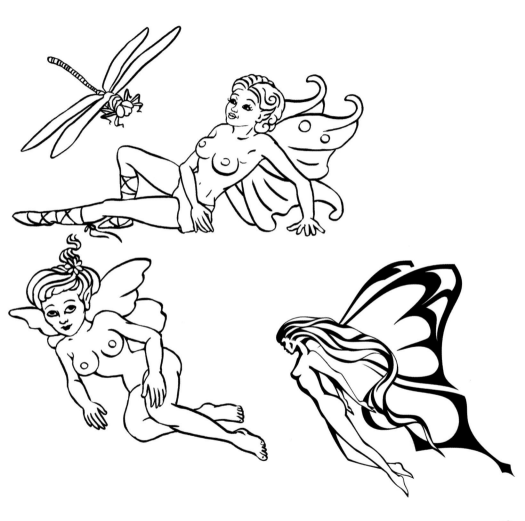

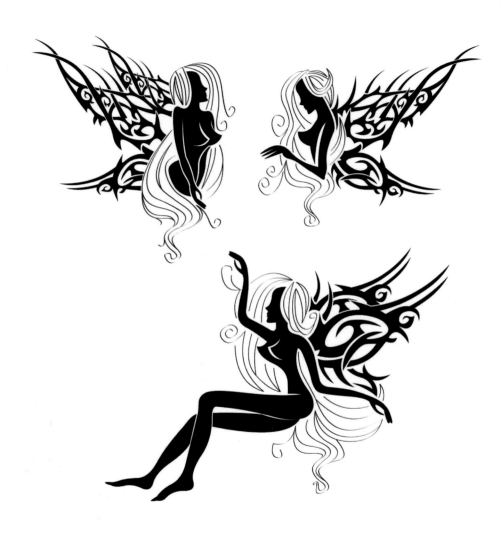

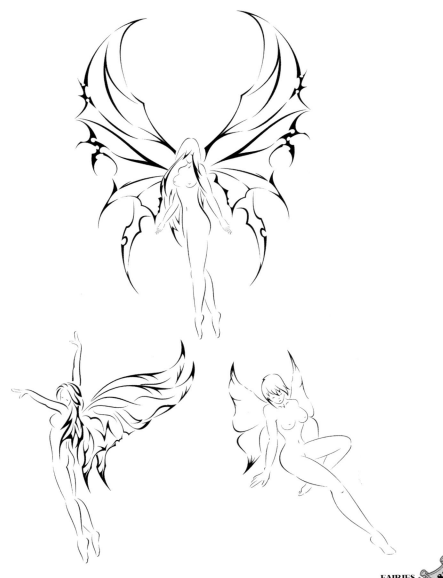

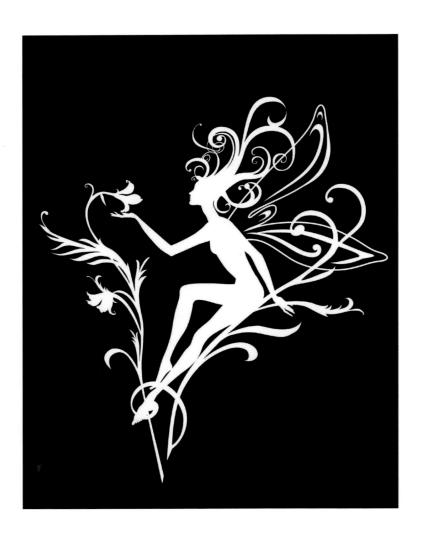

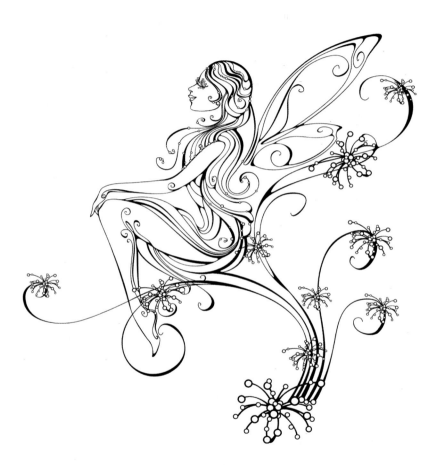

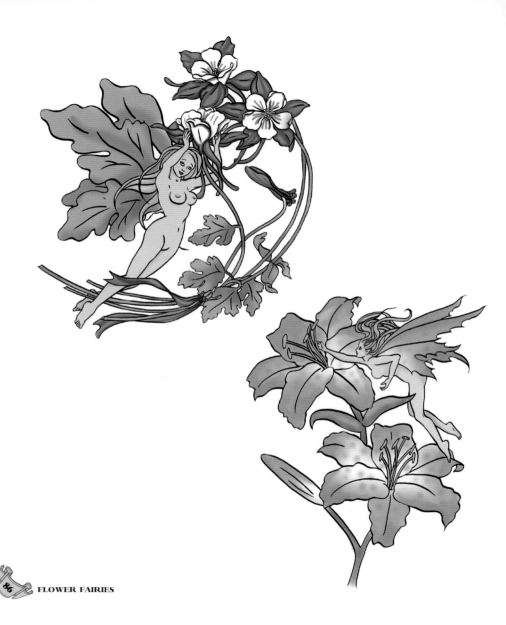

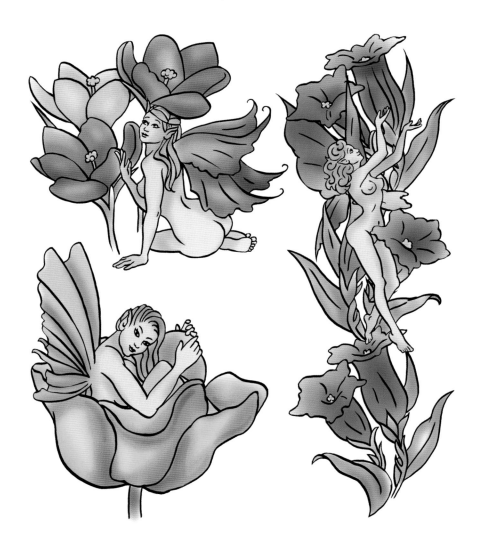

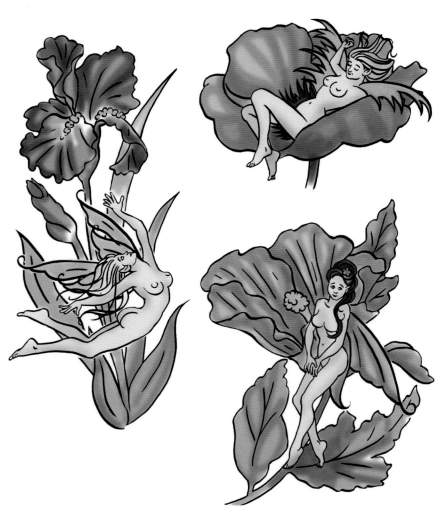

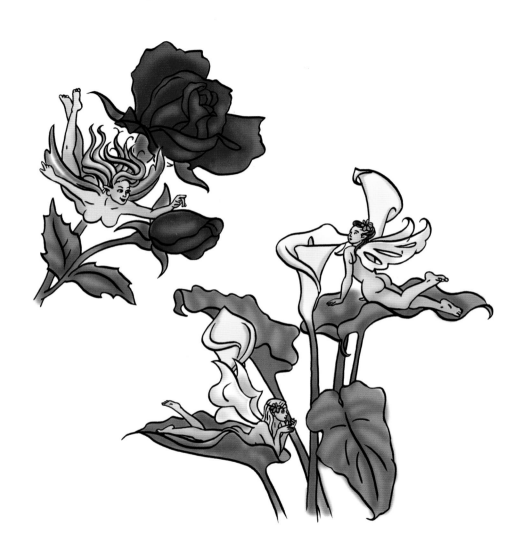

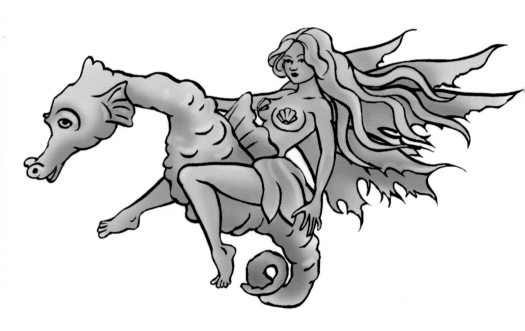

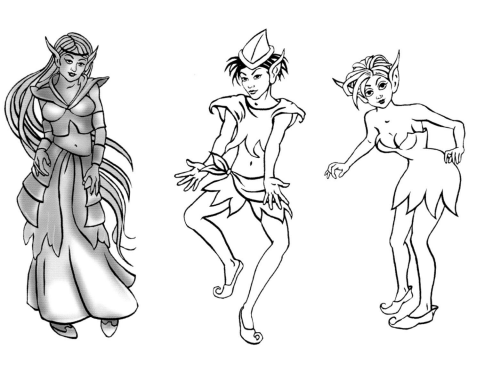

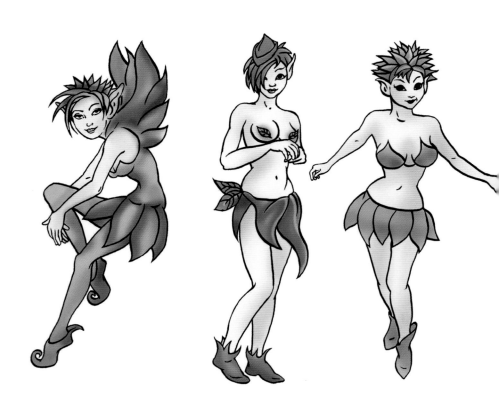

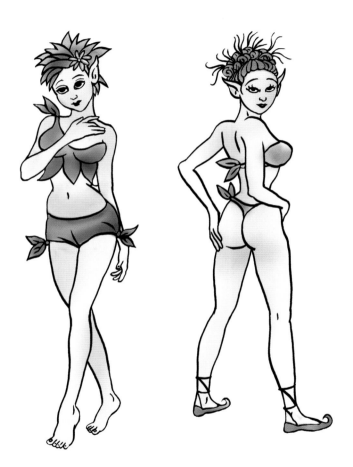

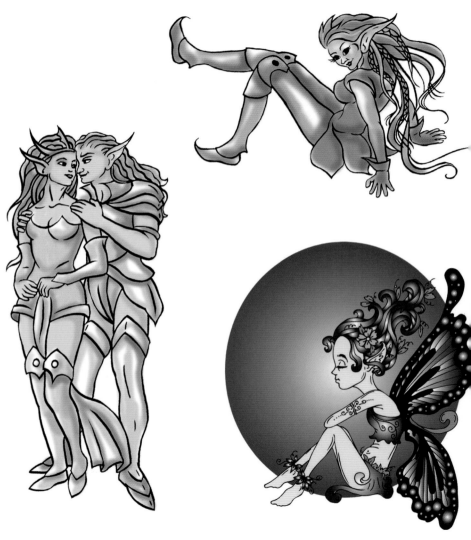

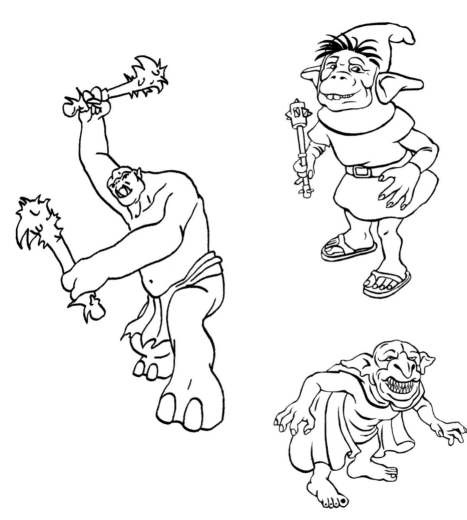

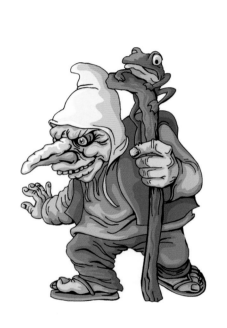

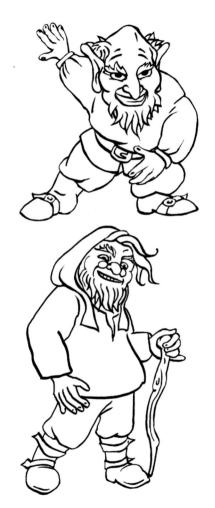

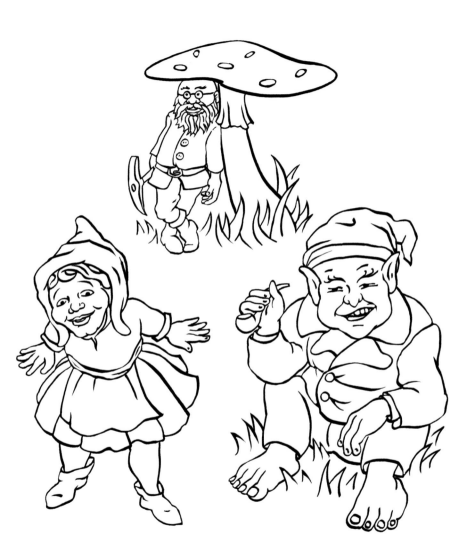

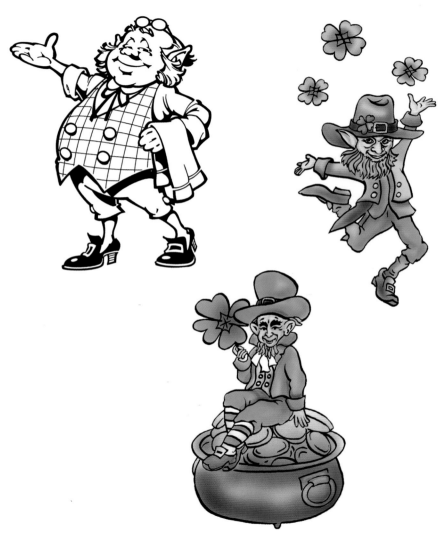

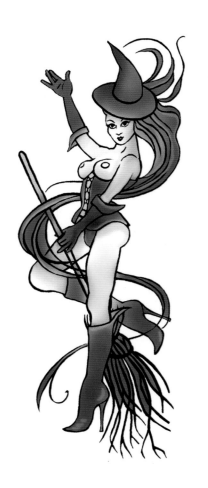

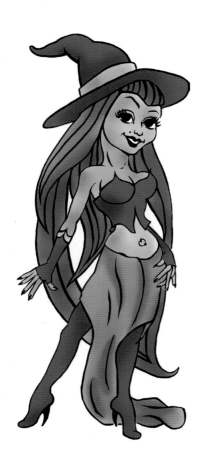

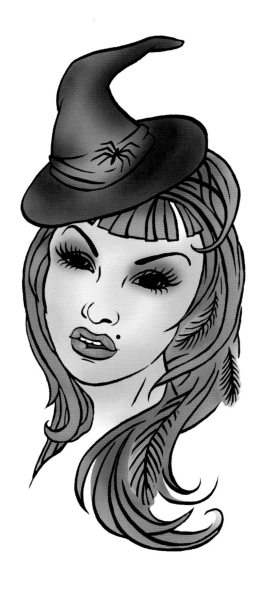

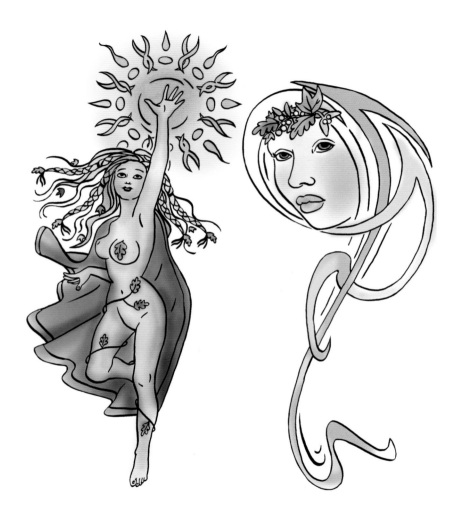

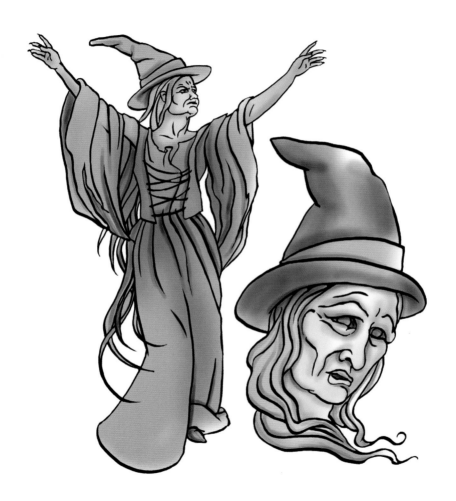

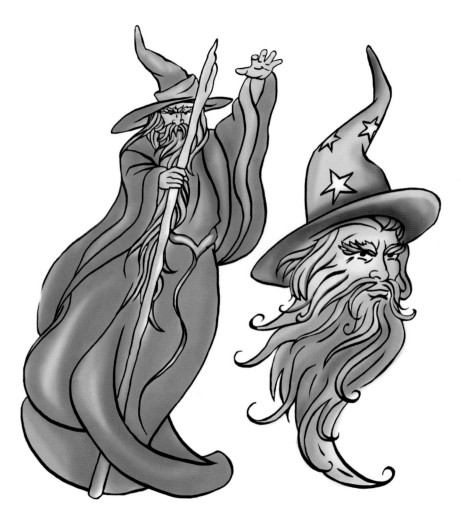

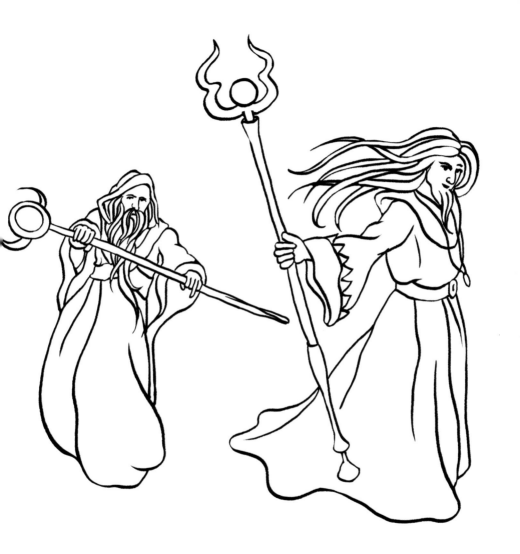

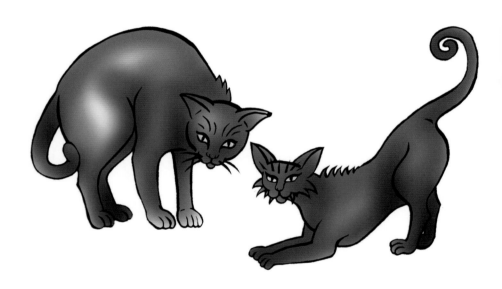

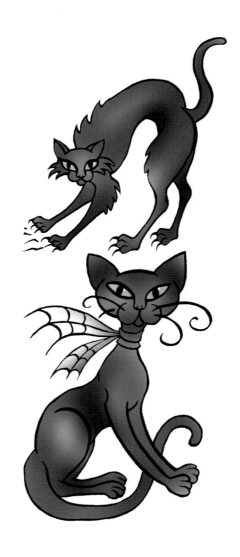

SEXY CAT

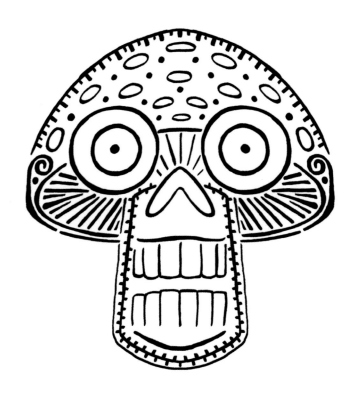

TOADSTOOLS

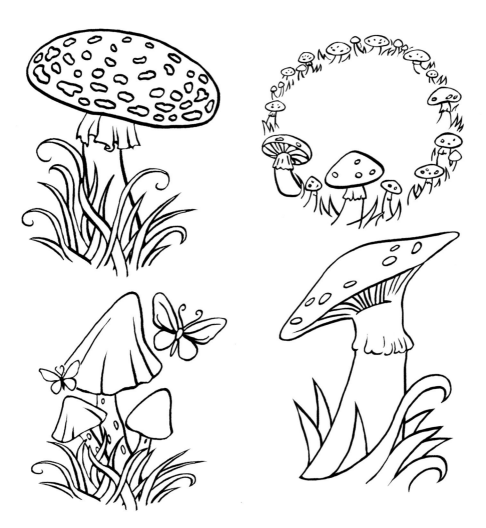

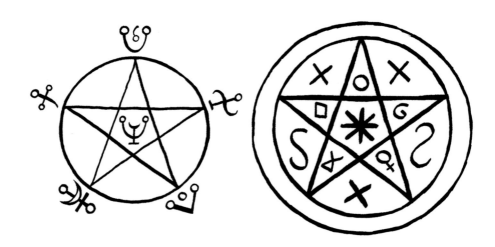

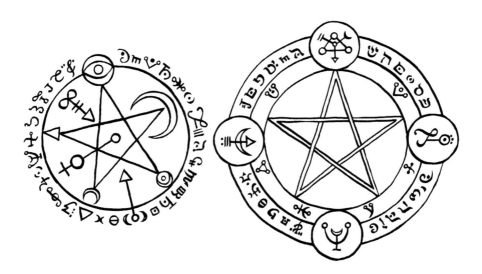

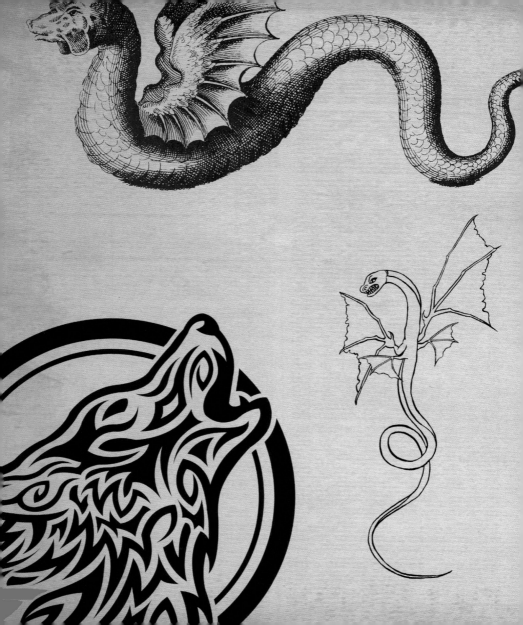

MONSTERS AND BEASTS

In tattoo art, images of monsters and beasts are used psychologically and spiritually to scare away evil spirits, even though they themselves are representative of our darkest fears, chaos and disorder. Some of the most popular monster motifs are in fact gargoyles and grotesques with horns and wings; a feature of Gothic architecture, these are sited on churches and other buildings to keep bad spirits and demons at bay.

Sea serpents, beasts and behemoths are explored in all their glory here, from the sea creatures that capsize boats, through the basilisk with the power to kill at a glance, to classic horror fare – the werewolf, the flying monkey and the Japanese movie monster Godzilla. Serpents and snakes have long been associated with ancient rituals, poison and medicine, and in the East serpents – such as the multi-headed *nagas* – are guardians of temples, while in the West they are more often seen as signs of temptation and evil. In the tattoo world they are often considered to represent fertility, regeneration, wisdom and sexual potency. Another guardian is the three-headed Cerberus who sits at the doors to the underworld. Many animal monsters possess human-like features or are able to shapeshift. The Japanese kitsune is a fox spirit with magical abilities to assume human form, and can manifest as a trickster or as a guardian. The more tails it has, the wiser and more powerful; when it gains the ultimate nine tails, the fur becomes white or gold.

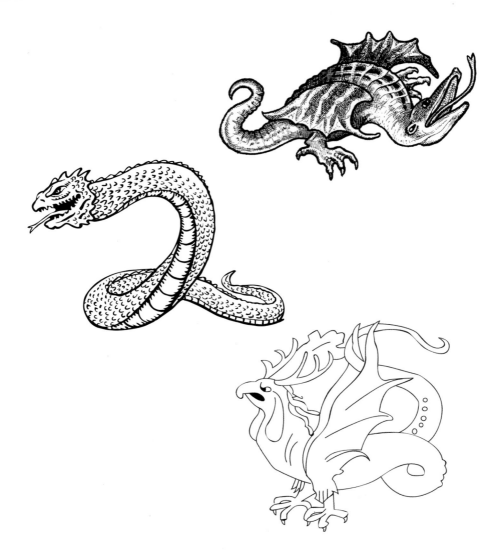

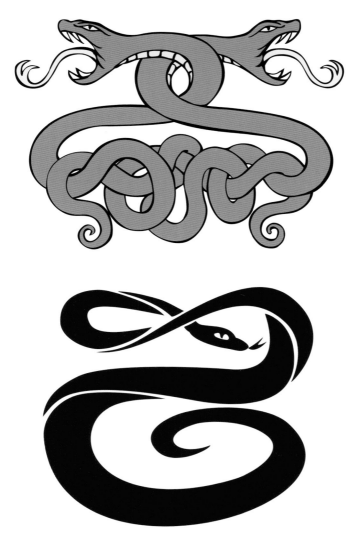

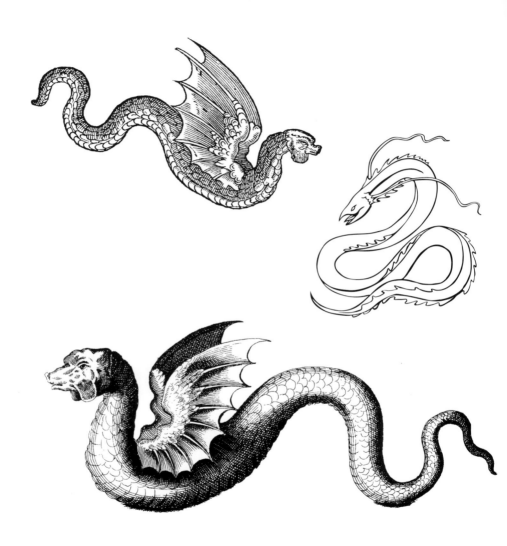

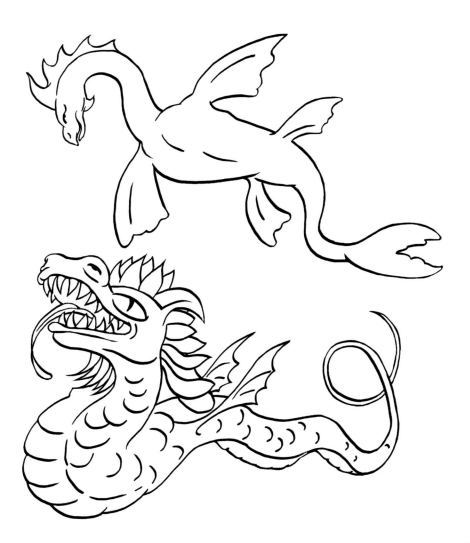

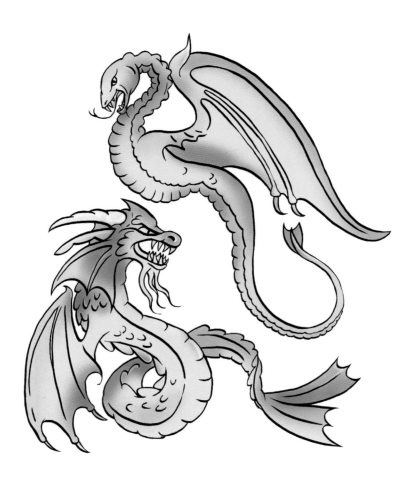

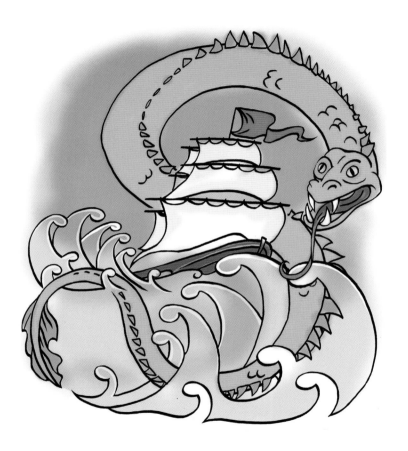

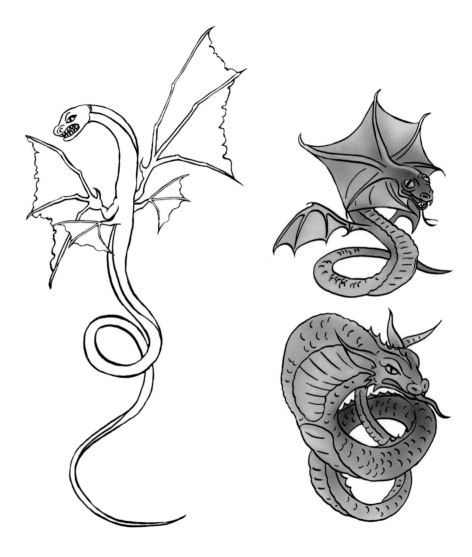

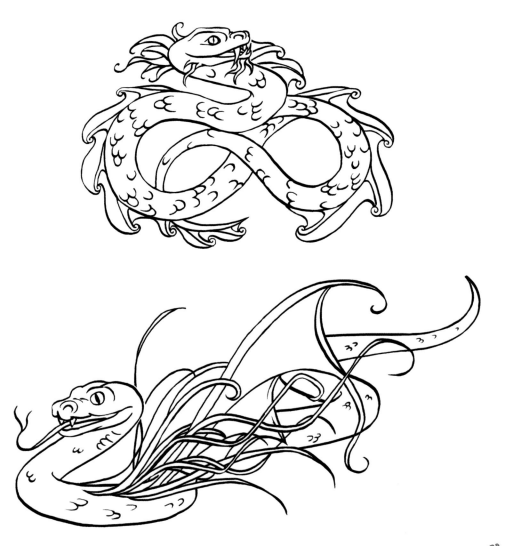

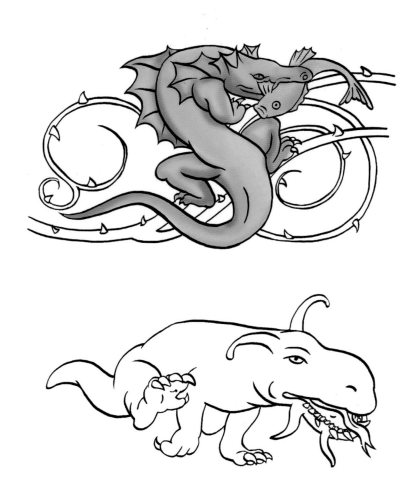

LIZARD MONSTERS

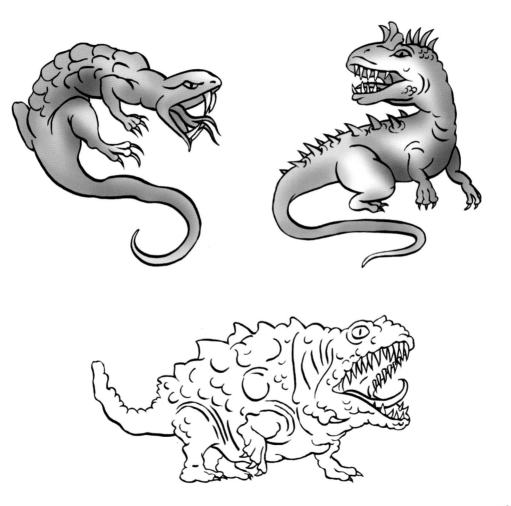

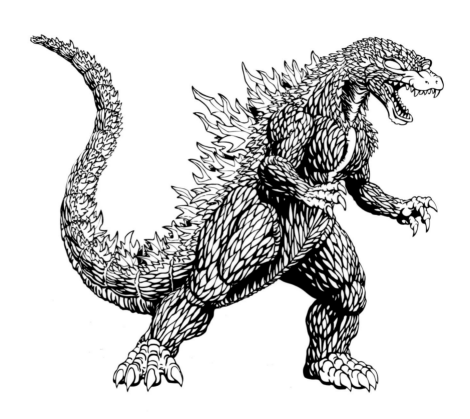

GODZILLA

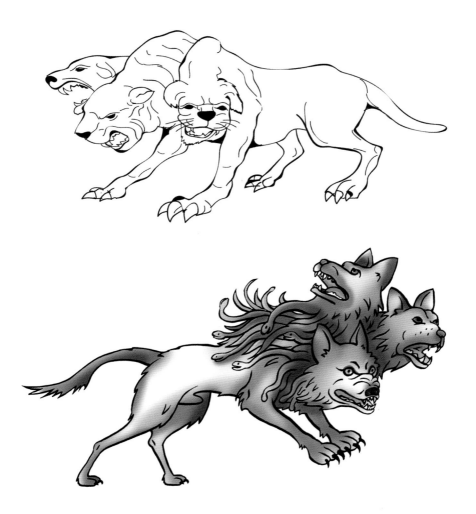

THE CERBERUS *133*

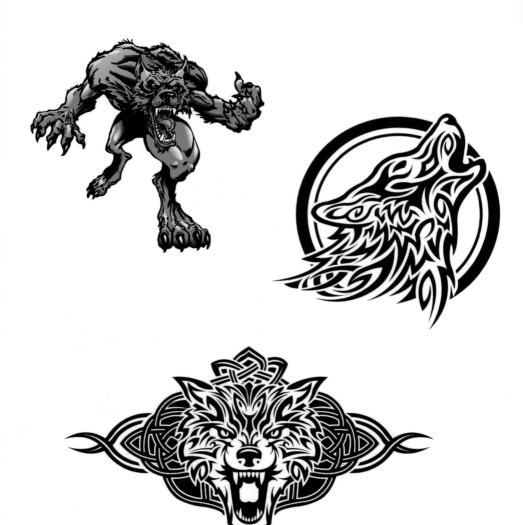

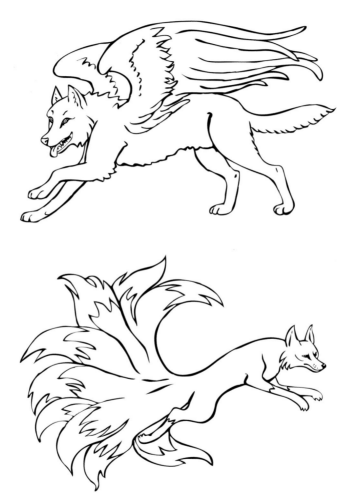

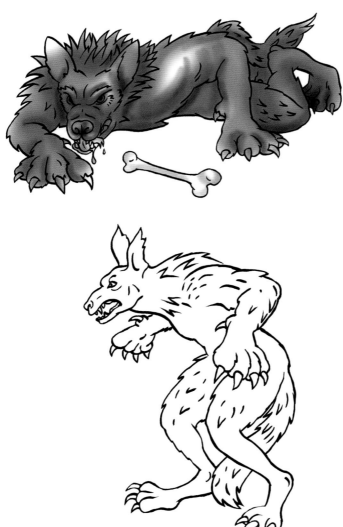

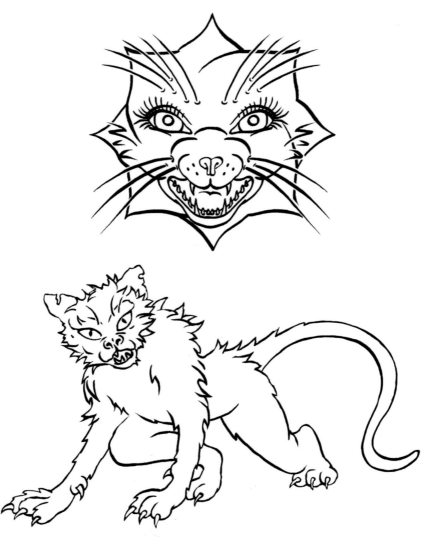

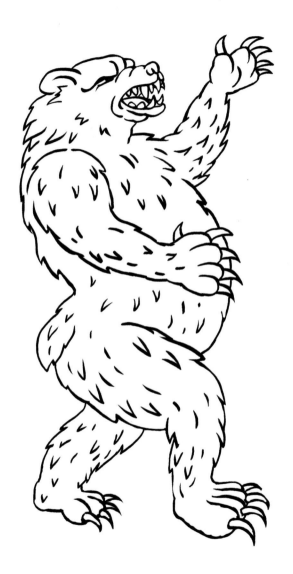

BEAR MONSTER 139

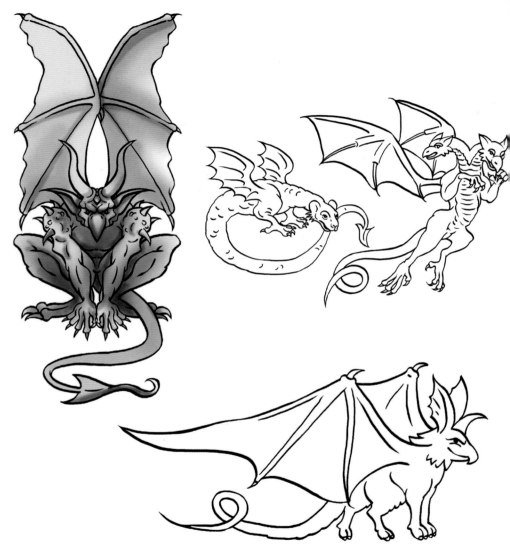

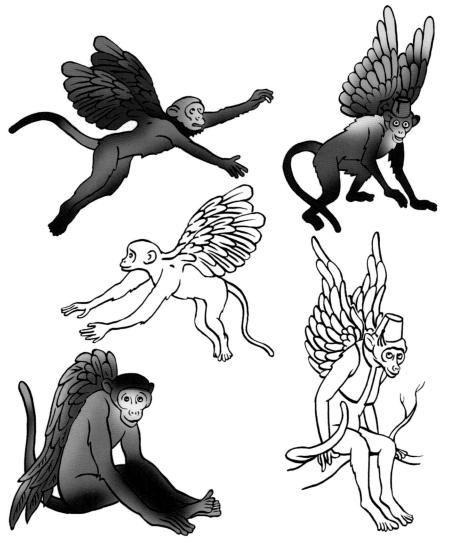

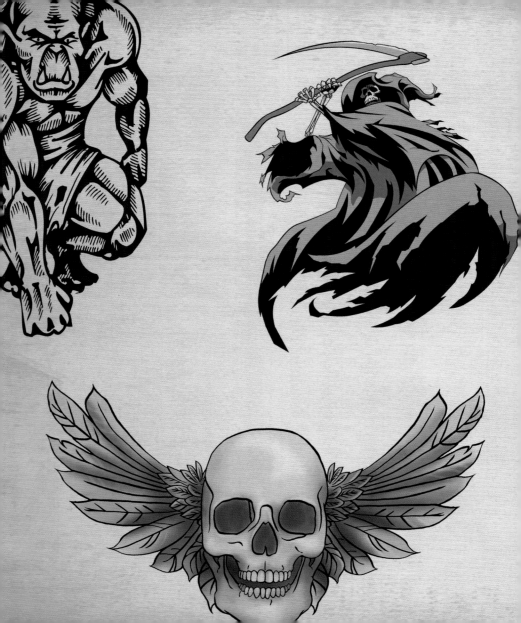

HEAVEN AND HELL

Visions from the underworld, the afterlife and heaven are shown on the following pages, including devils, demons and ghosts as well as angels and cherubs and the walking dead – vampires and zombies. Apart from religious significance, the angel is most often used as a memorial to a loved one who has passed away, or as a symbol of protection, peace or guidance. Directly associated with the heavenly and the divine, they are the carriers of souls and deliverers of God's will. Depictions of Satan in various guises are explored in tattoo art, from the horned and forked-tongued devil to bat-winged creatures. The devil is often included in scenes of seduction or hedonism.

A classic tattoo favourite, the skull represents death and serves as a *memento mori* – reminding us of our inevitable demise. Not only a symbol of eternity, it is also one of human vanity. Related imagery is the grim reaper or "angel of death", a personification of death itself. Cloaked and hooded, the skeleton holds a scythe, in order to sever the soul from the body, and an hourglass, which represents the inevitable passage of time that will lead to death. In addition, there are traditional Latin American "Day of the Dead" designs – dancing skeletons, Catrina figures (elegantly dressed female skeletons) and ornately decorated skulls that are used in this annual festival to honour the lives of those who have died and celebrate rebirth.

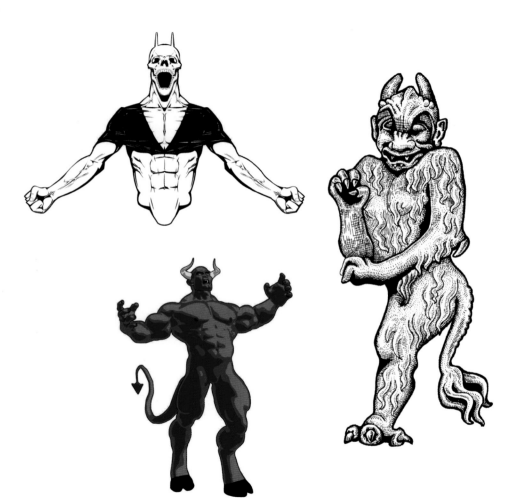

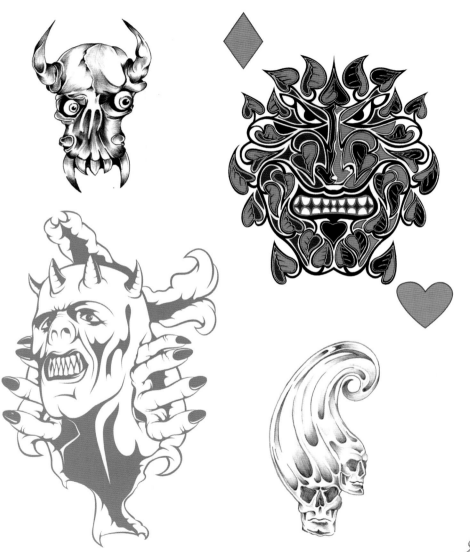

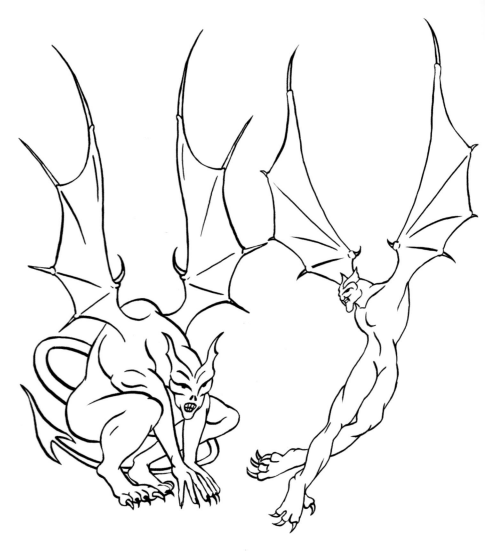

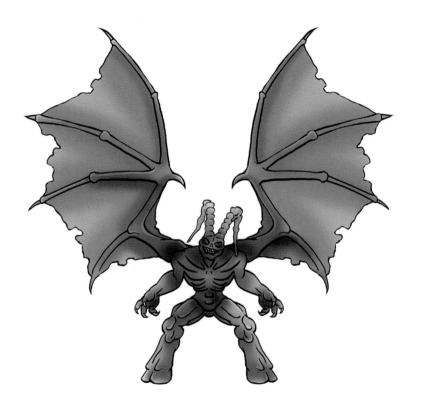

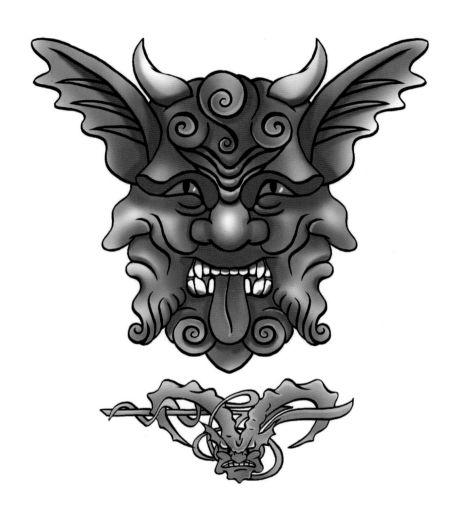

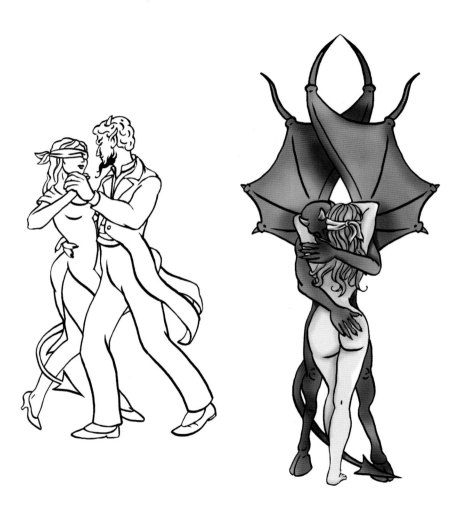

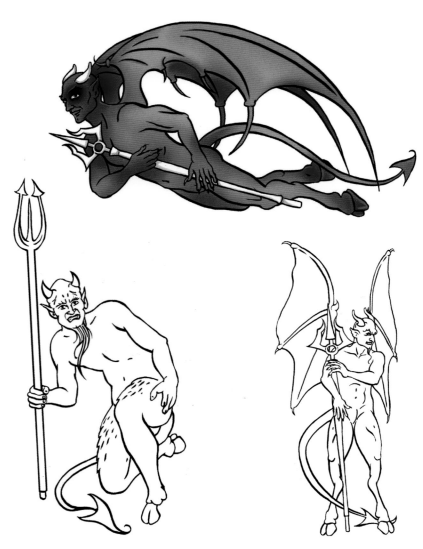

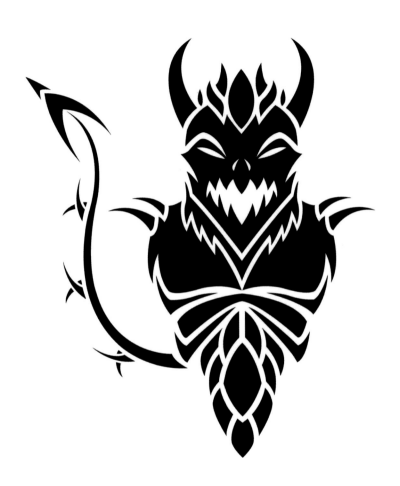

DEVILS 151

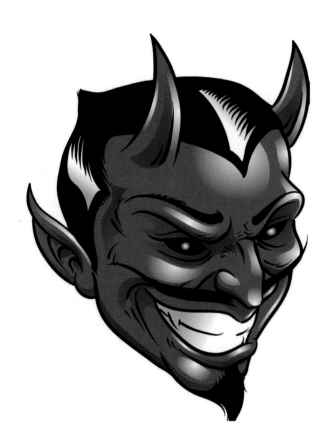

 DEVILS

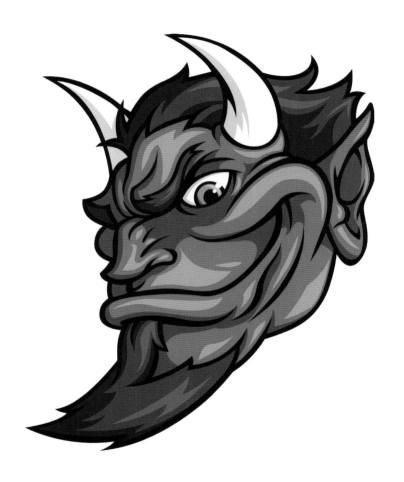

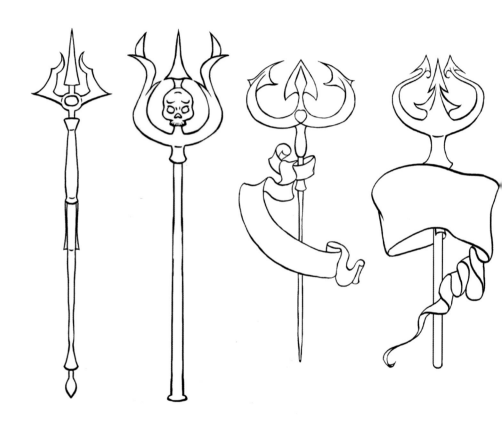

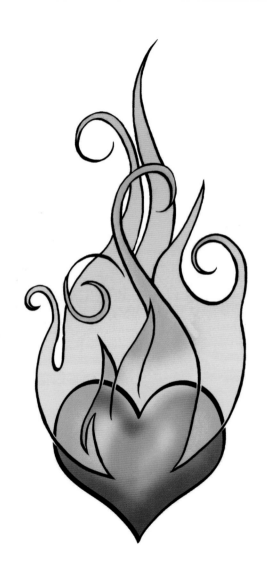

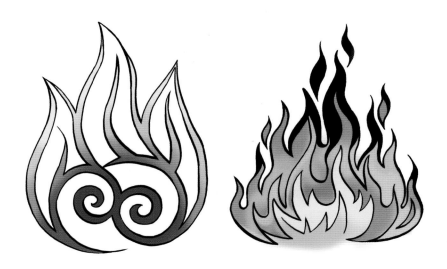

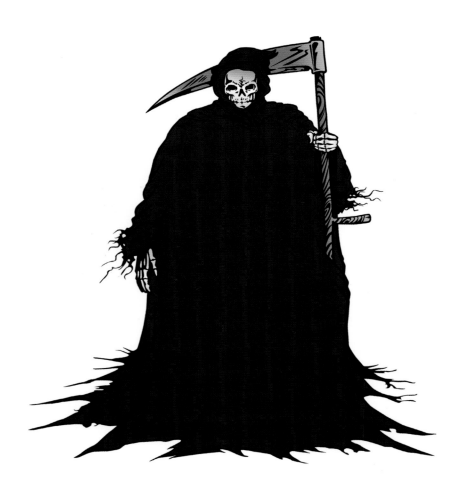

 GRIM REAPERS

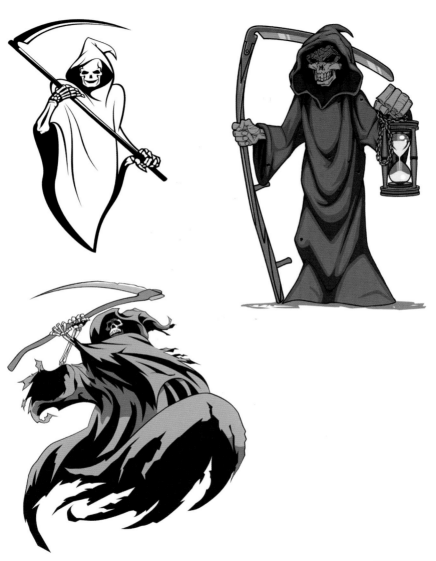

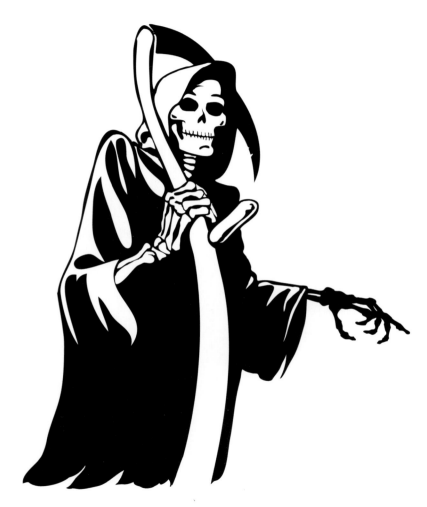

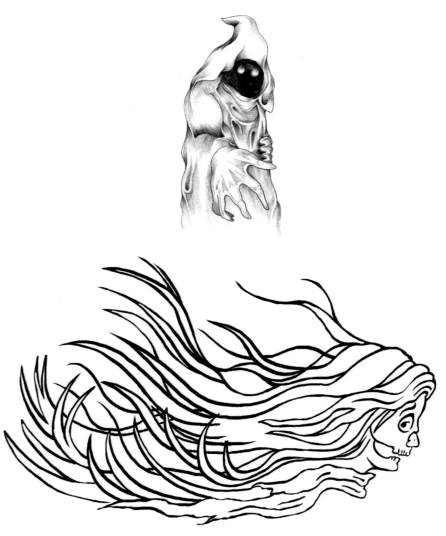

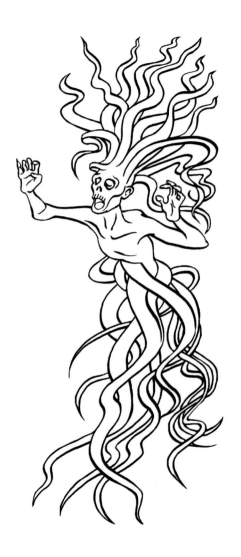

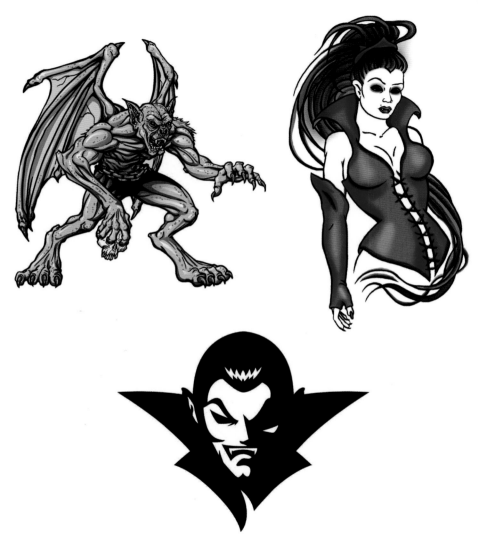

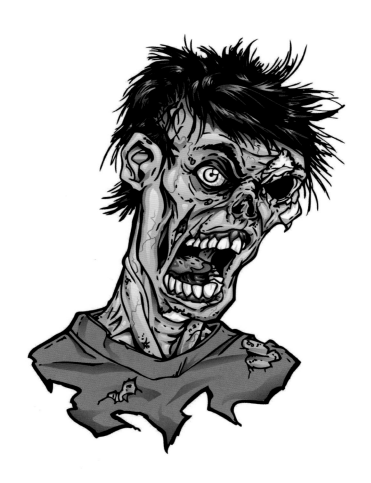

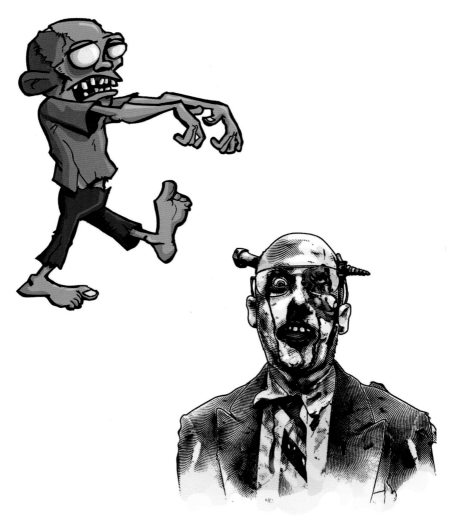

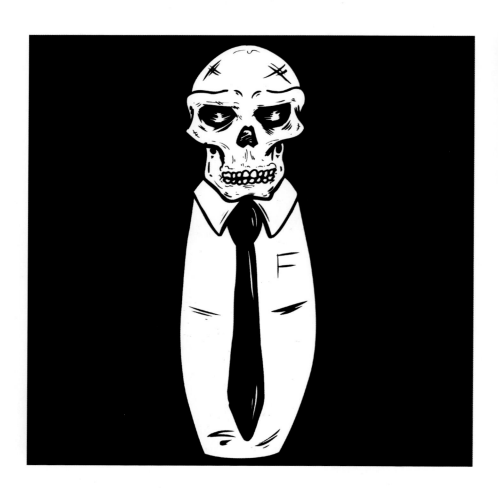

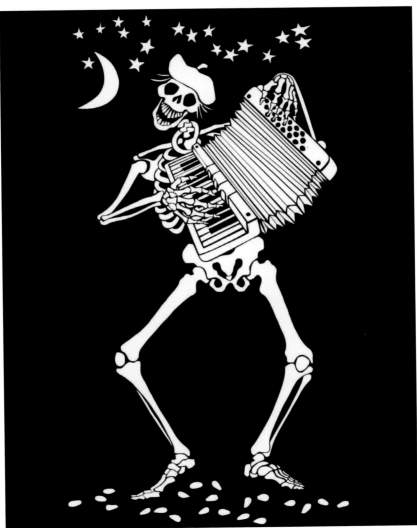

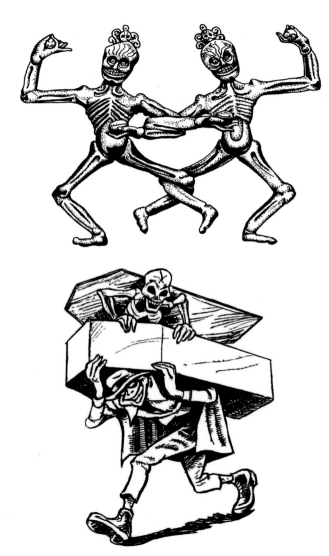

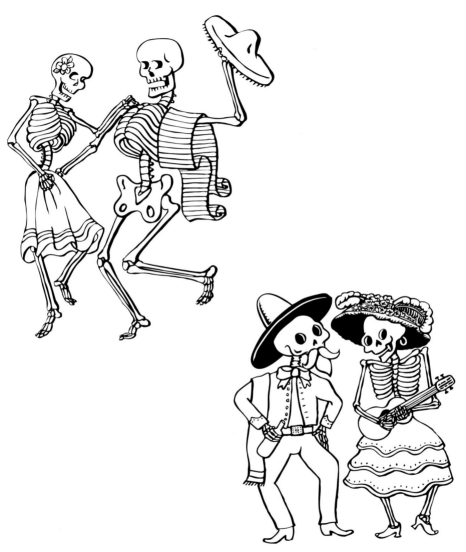

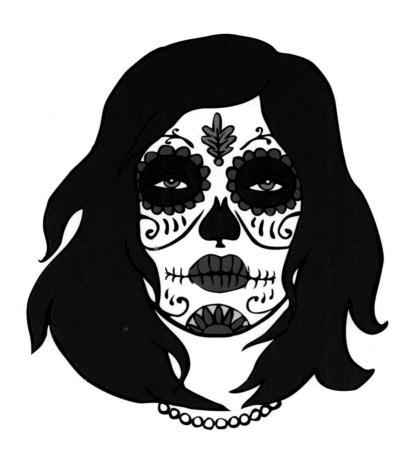

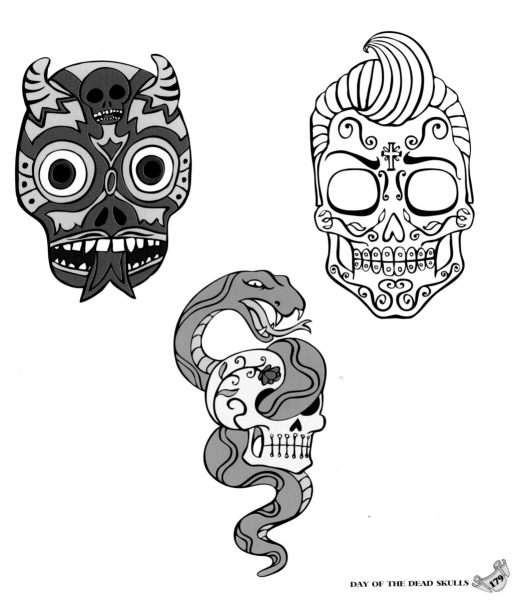

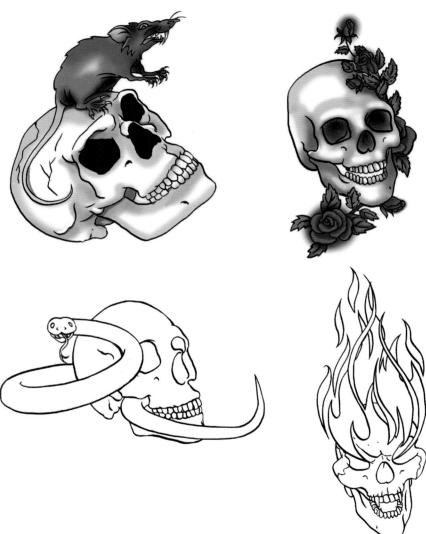

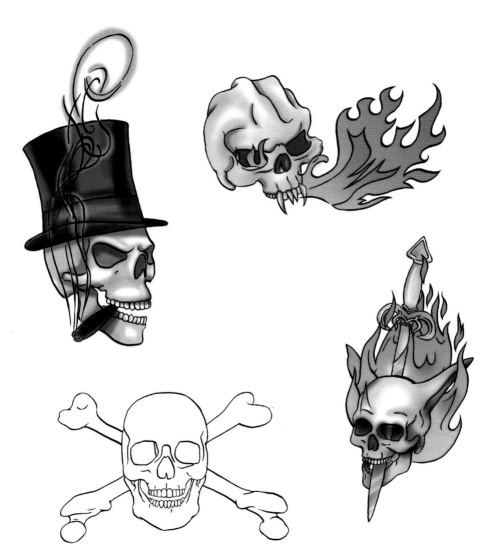

SKULLS 181

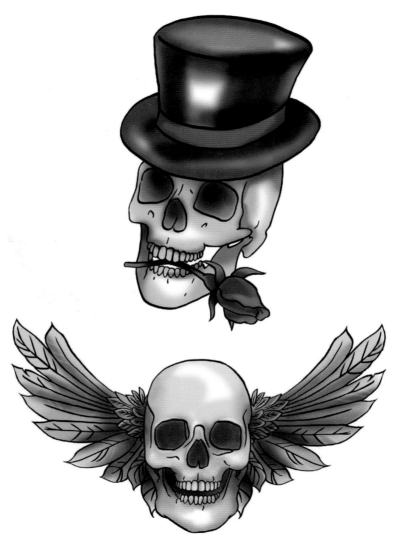

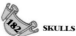

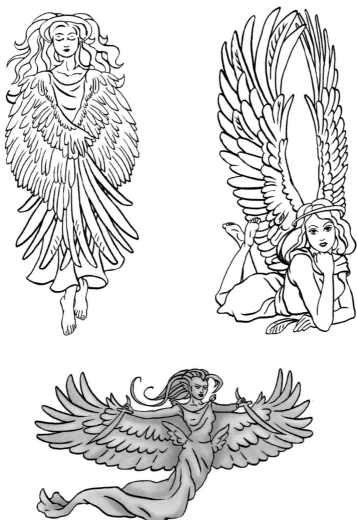

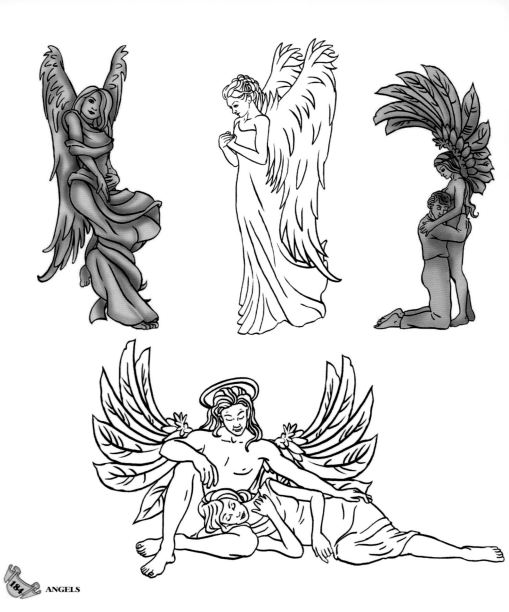

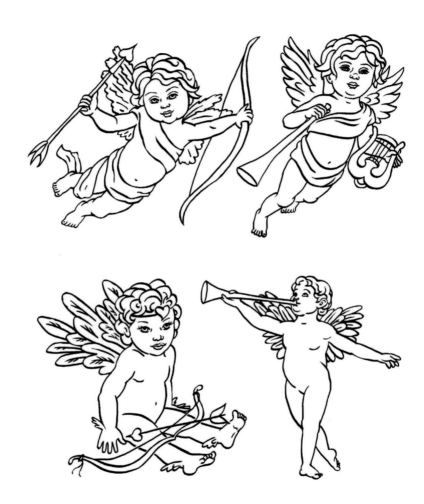

CHERUBS AND CUPID

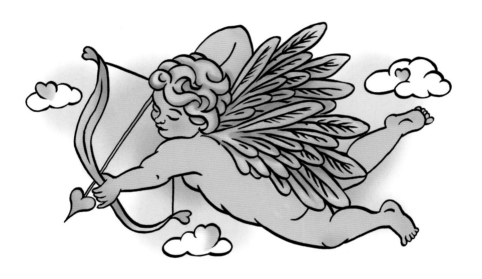

 WINGS

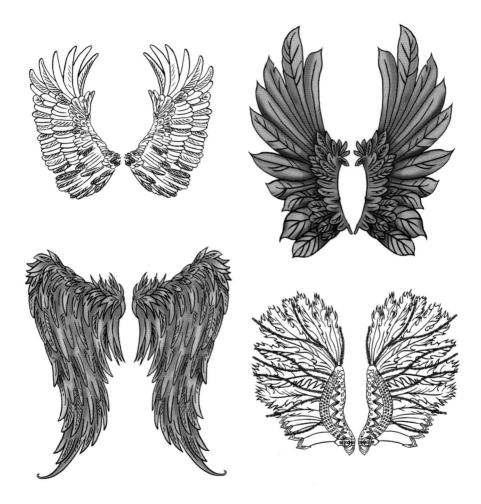

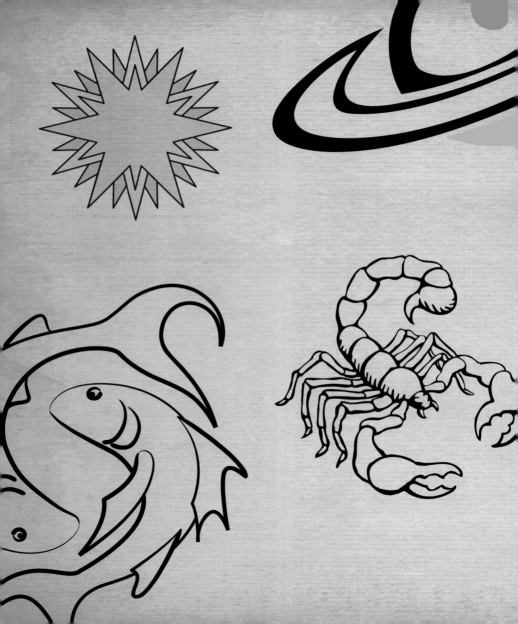

PLANETS AND STARS

In this chapter you will find, along with both symbolic and figurative representations of the zodiac, an assortment of images for planets and stars. The sun, worshipped as a life-giving force in almost every major civilization in history, is associated with gold, wealth, achievement and strength, whereas the moon symbolizes the subconscious, intuition, emotion and mystery; the ringed Saturn represents discipline and control. The sun and moon joined as one signifies a union of male and female – yin and yang – forces.

The meaning of any particular star depends upon its number of points. The five-pointed pentagram indicates protection and balance and is often associated with the military but can also represent the five elements – earth, wind, water, fire and spirit. The six-pointed star, the Star of David, is a symbol of the interaction between God and Man; the seven-pointed star is associated with the seven planets of astrology and the seven Hindu chakras; and the eight-pointed star, found in the *I Ching*, is a symbol of completeness and regeneration. Shooting stars usually mean wishes, or a brief moment in life that's passed, while comets or falling stars denote a divine quality bestowed on the earthly. Astrological signs are held to represent twelve basic personality types or characteristic modes of expression, and as such many people identify strongly with their star sign.

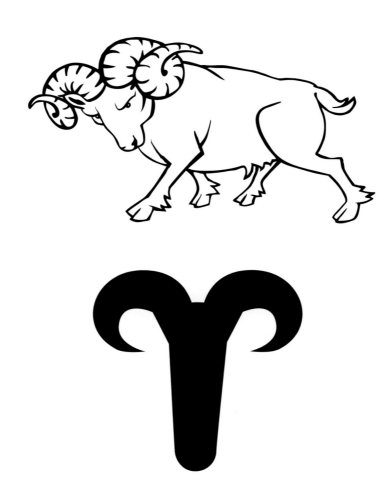

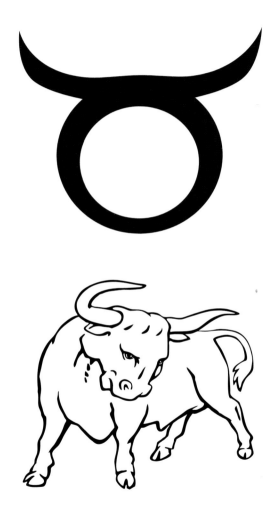

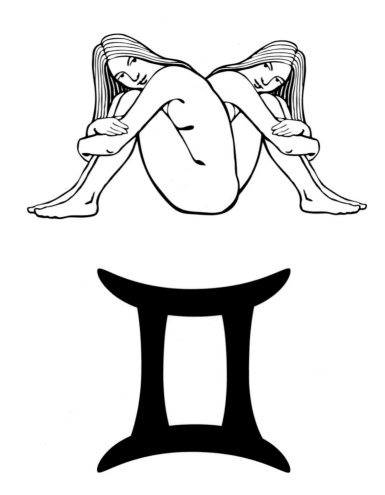

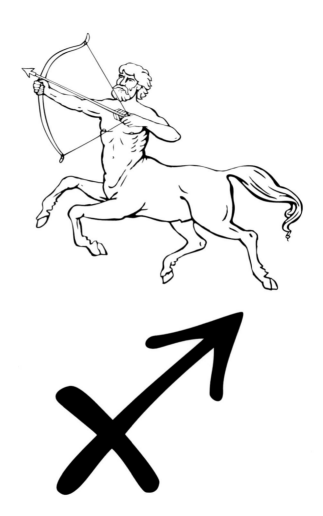

THE ZODIAC : SAGITTARIUS

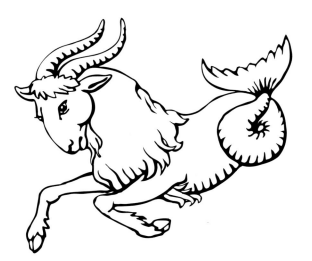

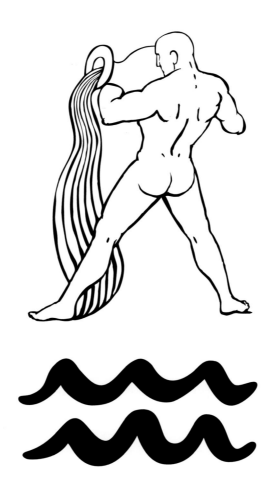

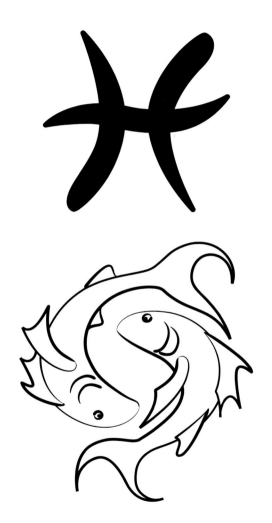

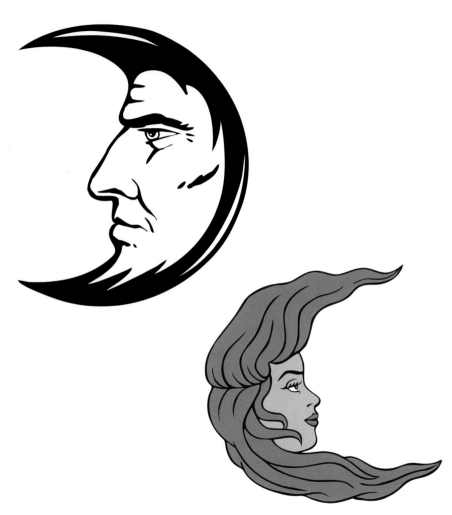

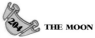

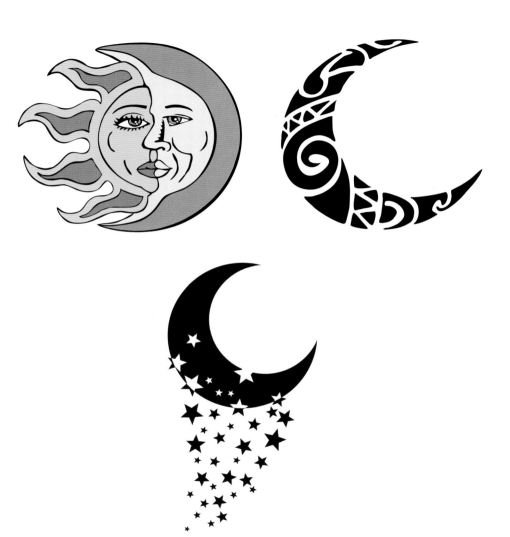

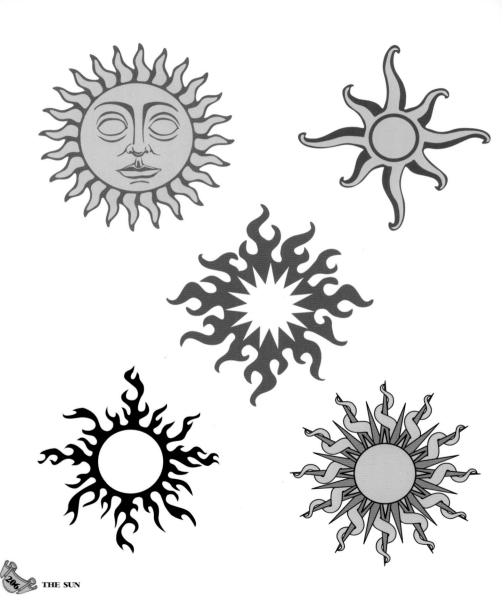

THE SUN

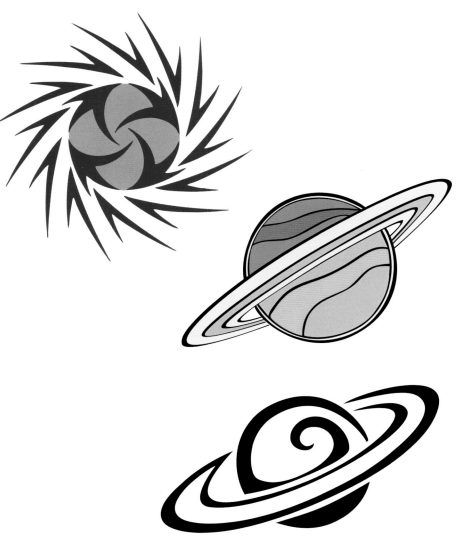

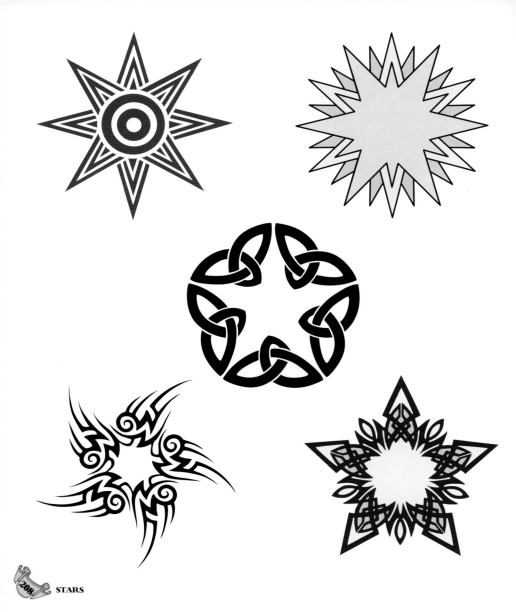

STARS

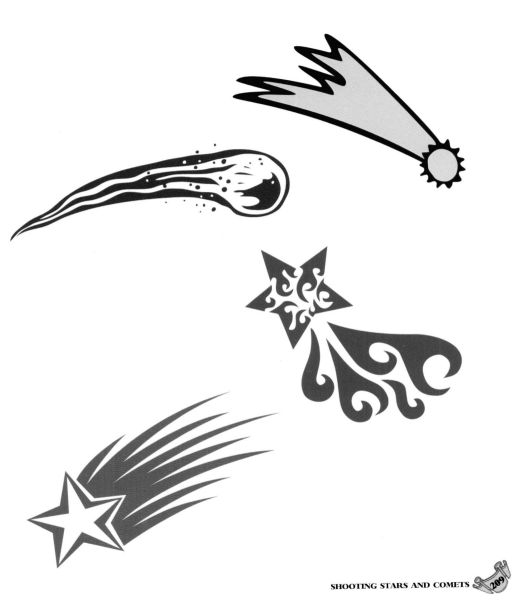

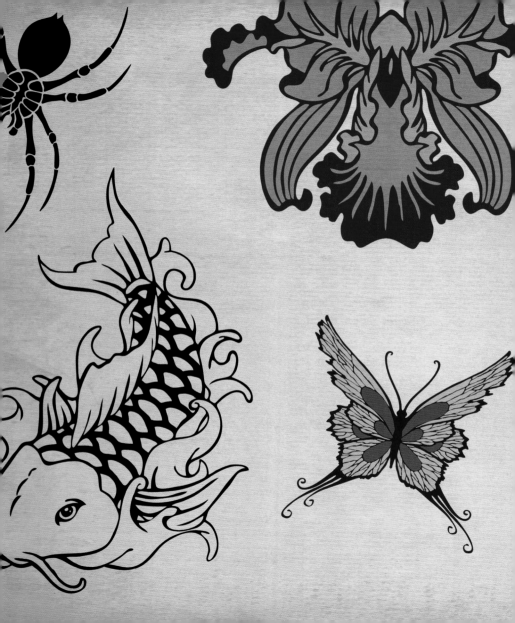

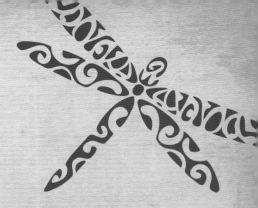

NATURE

Fantasy art imparts a heightened beauty to images from the natural world – insects, flowers and animals are more otherworldly than they are in real life. Butterflies are popular designs because they represent inspiration, freedom and transformation within the three cycles of life – birth, death and rebirth. With their iridescent wings and ability to bridge water and air, dragonflies are a mark of magical, harmonious beauty and many Asian cultures see them as a symbol of joy and happiness. Similarly, in the Far East, koi carp represent love and good fortune, and goldfish signify gold coins.

Inhabitants of the sky, birds of every sort are found in tattoo art: soaring eagles represent strength, loyalty, honour and freedom, while hummingbirds signify energy and infinity and swallows stand for voyage. On the darker side of nature is the spider – a popular biker, pagan and punk symbol. Due to it's web-spinning powers, the spider is associated with treachery, mystery and patience.

Flower symbolism is a vast subject, both in the types of flowers depicted and the colours chosen – red roses for love, lilies for fertility and motherhood, pansies for remembrance and sunflowers for wealth are just a few examples. On the following pages you will find tattoo ideas for single-stem flowers, as well as garlands, vines, leaves and thorns.

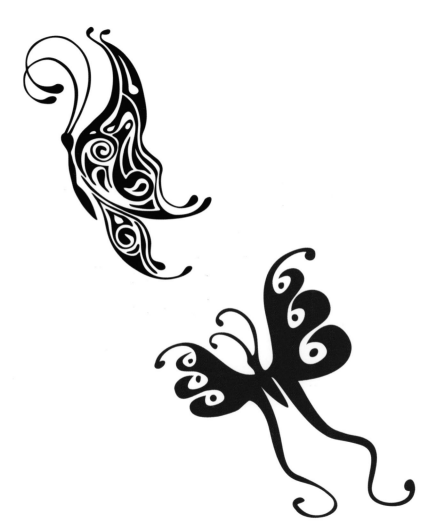

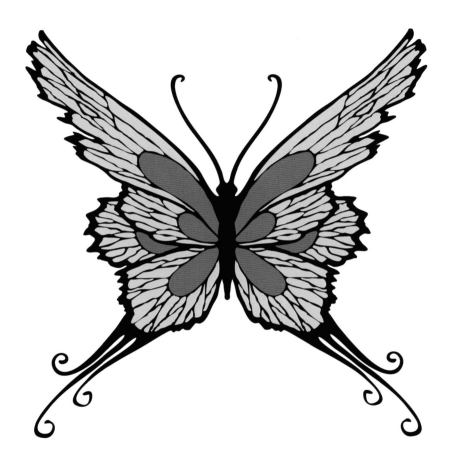

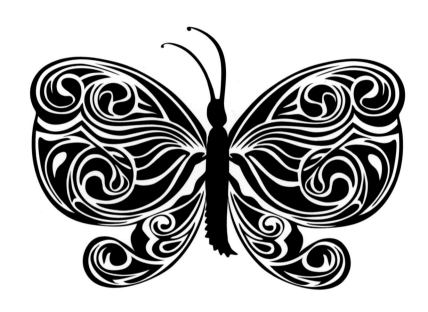

BUTTERFLIES, DRAGONFLIES AND MOTHS

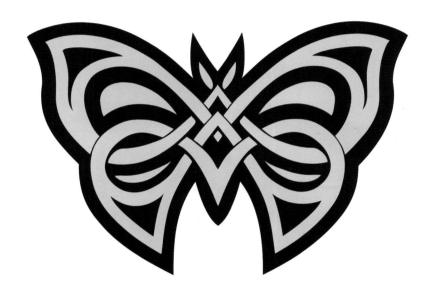

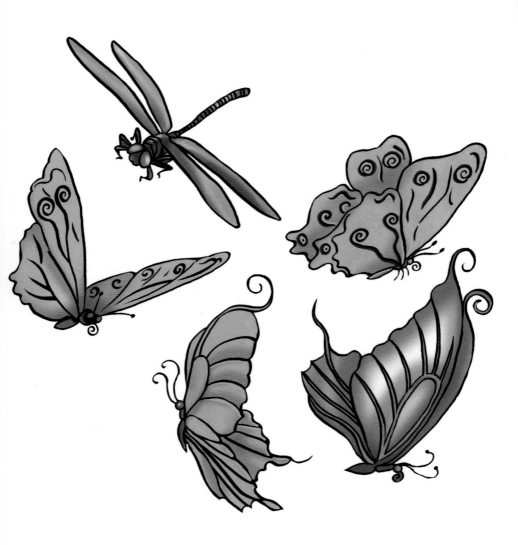

BUTTERFLIES, DRAGONFLIES AND MOTHS

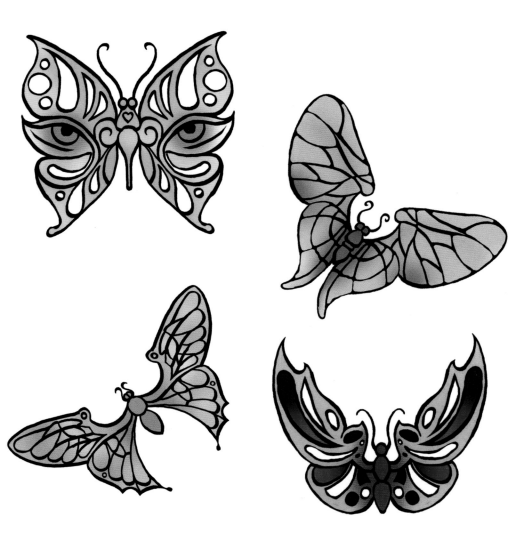

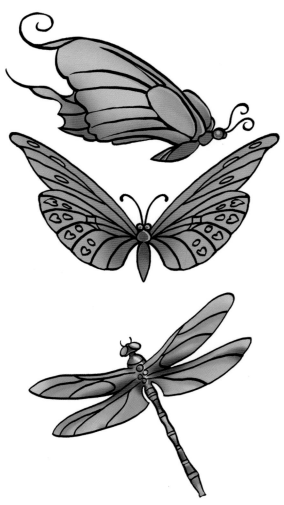

BUTTERFLIES, DRAGONFLIES AND MOTHS

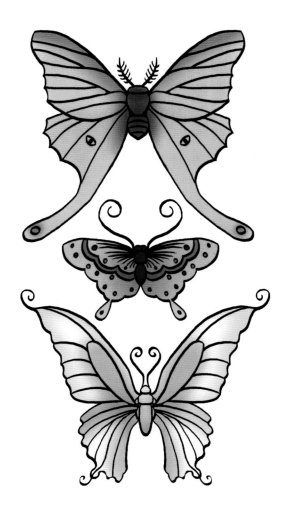

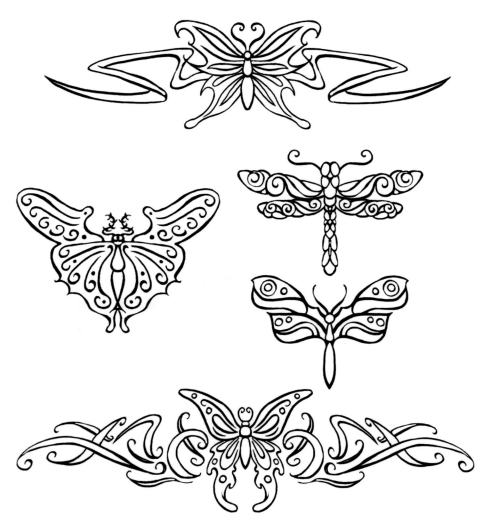

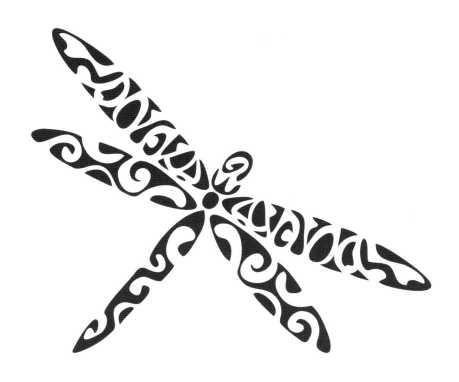

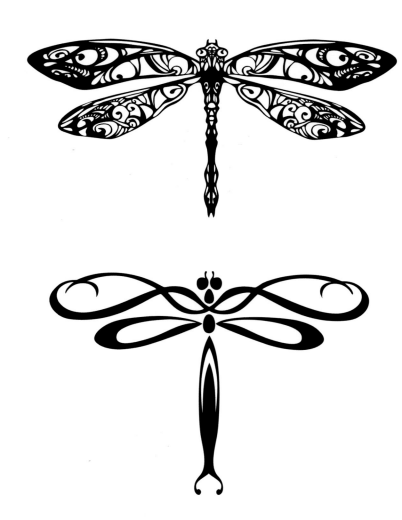

BUTTERFLIES, DRAGONFLIES AND MOTHS

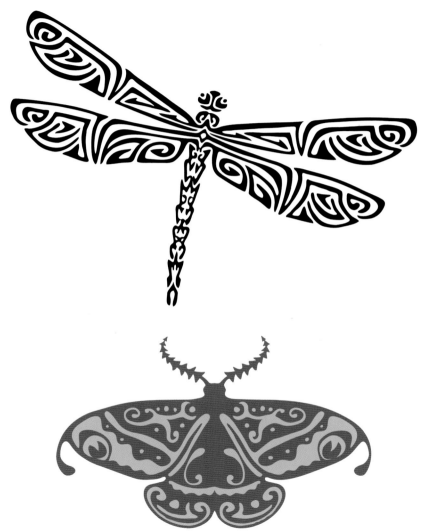

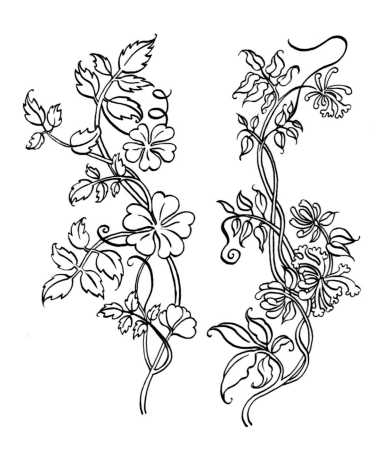

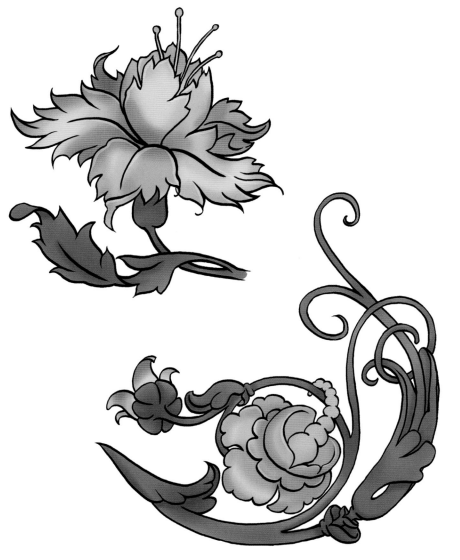

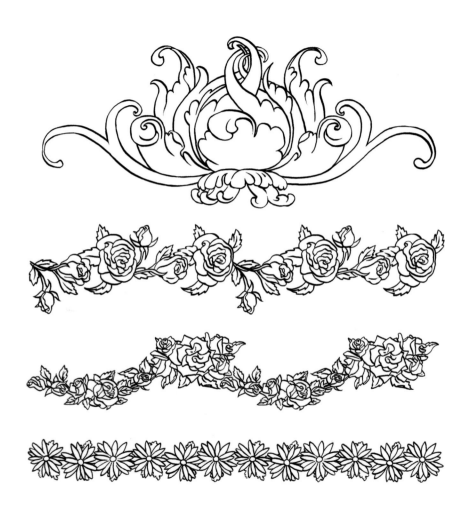

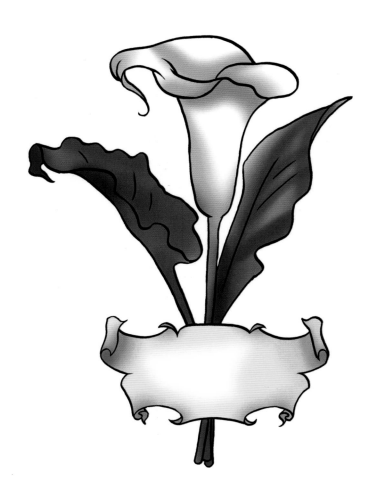

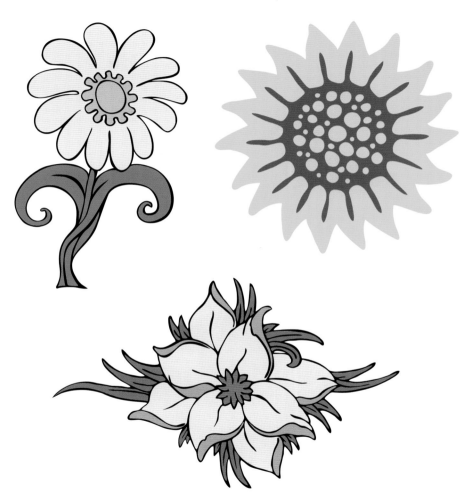

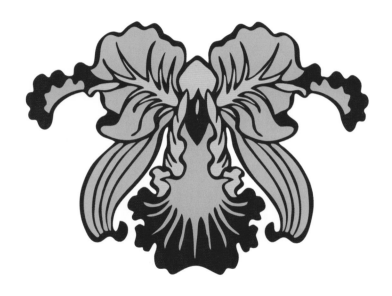

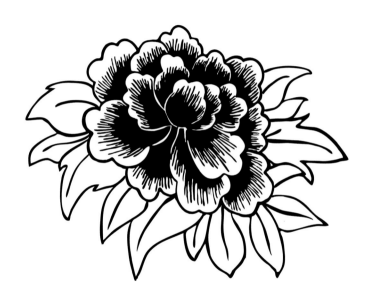

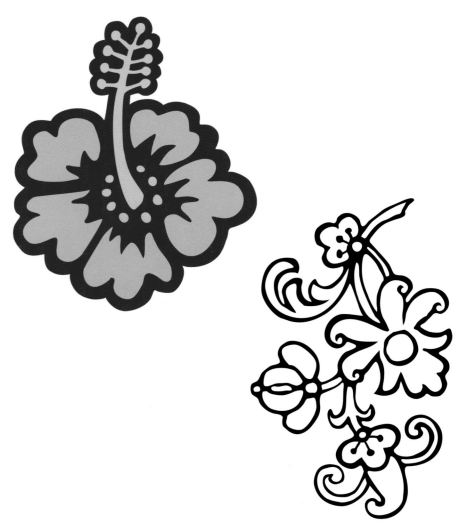

 PLANTS AND FLOWERS

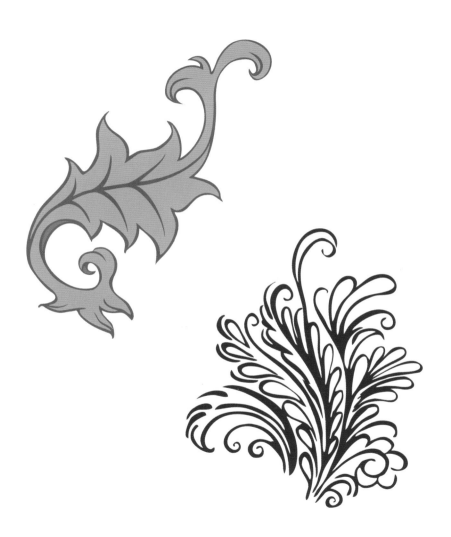

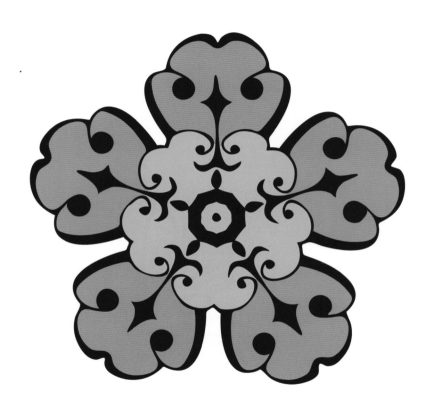

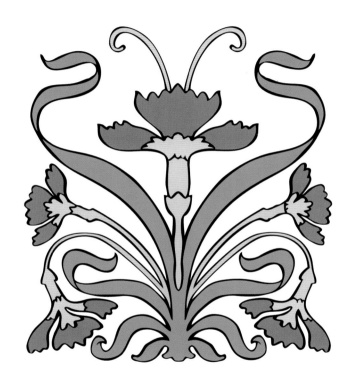

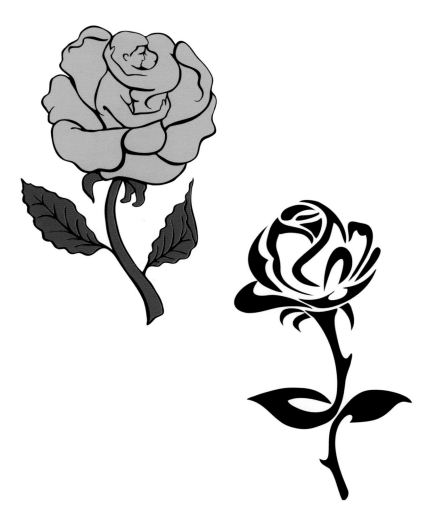

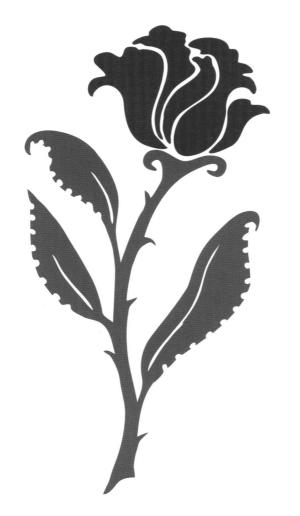

 THORNY HEART

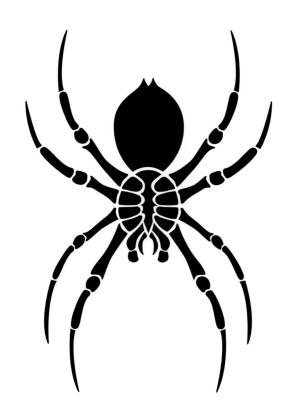

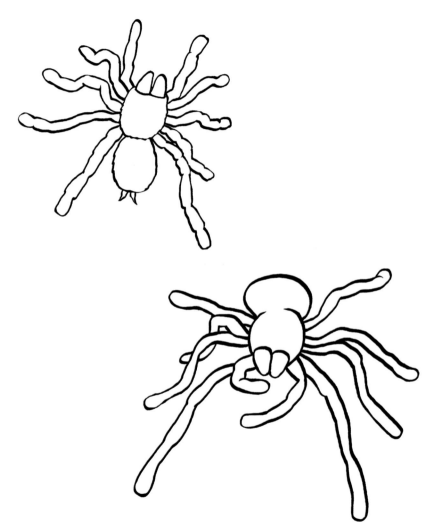

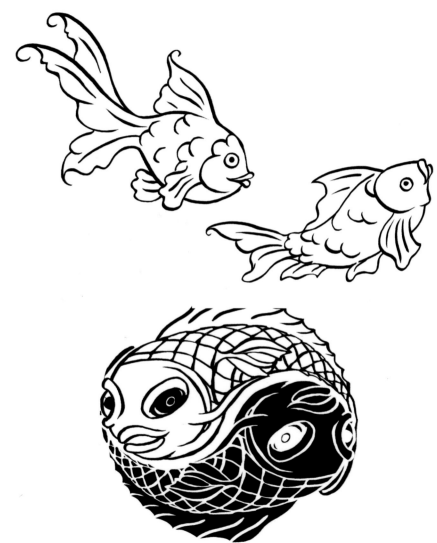

FISH

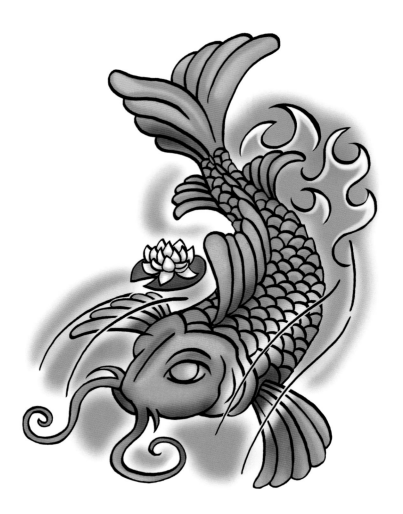

FISH 245

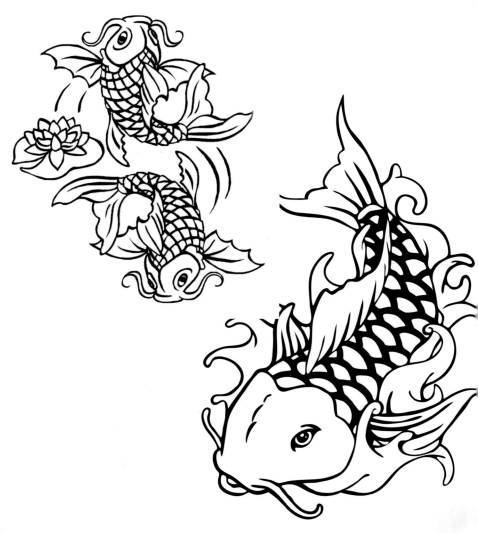

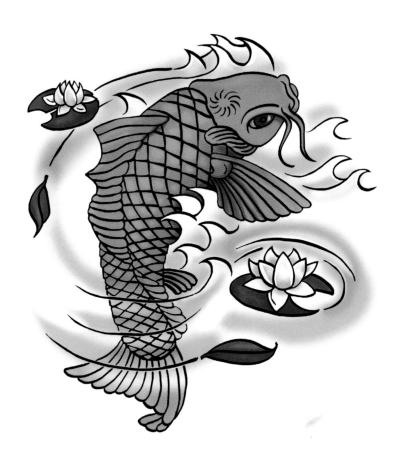

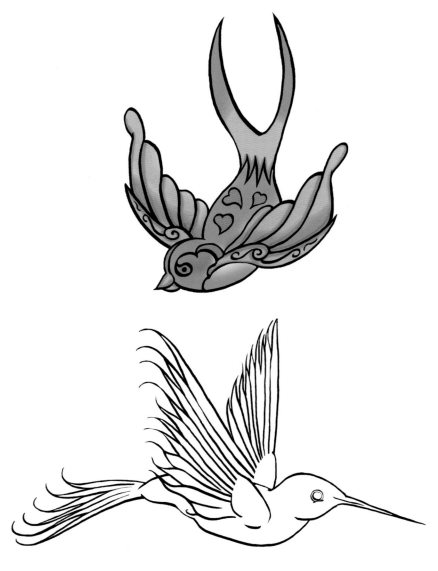

SWALLOW AND HUMMINGBIRD

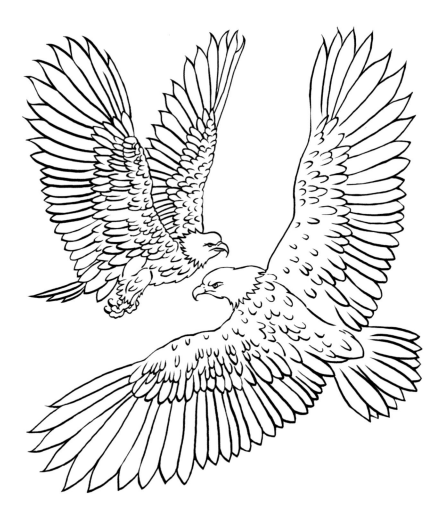

TEMPORARY TATTOOS

Decals, Henna and Body Paints

Temporary tattoos can be drawn, painted or airbrushed on, or transferred to the skin in the form of a sticker or decal made with vegetable inks. The variety and quality of decal-type transfer tattoos has become much more sophisticated than in the past; they are usually applied by placing the image face-down against the skin, moistening the backing and pressing down firmly before peeling off the backing layer. You can create your own transfers using tattoo print transfer paper and a colour laser printer, though you will need to reverse the image. Although these designs are waterproof, they can be removed easily with oil-based cream and will last anywhere from one or two days to several weeks.

Airbrush tattoos use a stencil and an airbrush gun to reproduce the image. They can closely resemble a real permanent tattoo and allow for shading and complicated artwork. Lasting as long as a week or two, they can be removed with an oil- or alcohol-based product.

Body paints can be used freehand on the skin or with a stencil or airbrush. Nontoxic and nonallergenic, these are available as face-painting kits, professional body paints (such as those by Kryolan or Mekon brands), or as quality cosmetic products from companies such as Make Up For Ever or MAC. When painting or airbrushing, always draw the outlines first and fill in with colour and shading afterward.

Henna, a paste made from the plant *Lawsonia intermis*, can also be used to create temporary tattoos. Traditional henna (mehndi) designs are drawn in delicate patterns on the hands and feet and the paste stains the skin in reddish, brown shades that gradually fade. They usually last from several days to a month.

- Always test a small amount of body paint or henna on the skin first and leave for 24 hours to see if there's any adverse reaction. If any rash or irritation develop, do not use the product.

PERMANENT TATTOOS

Created by injecting small amounts of coloured ink in the top layers of the skin, usually with a tattoo gun, these tattoos last a lifetime. As the machine moves across the skin, the needle moves quickly up and down, injecting the ink in tiny dots. Because the needle pierces the skin, there will be some blood, but if done correctly should be minimal. For this reason, however, permanent tattoos carry a risk of blood-borne diseases. Permanent tattoos can also lead to skin infections, either because the needle carries bacteria or because the damaged skin lets infection in from other sources. Always go to a reputable and licensed tattoo artist; unsterile tattoo needles and equipment can carry skin infections caused by *Staphylococcus aureus* ("staph") bacteria and blood diseases including tetanus, tuberculosis, hepatitis C, hepatitis B and HIV. Ensure you visit the premises before you make an appointment and check to see the facilities are clean and a license is dated and displayed.

Although permanent tattoos allow you to make a personal statement or commemorate some special event, think long and hard before you make a decision. Removing one is a painful and expensive procedure. The preferred method, laser removal, can take 7 to 12 sessions and will usually lighten the tattoo rather than remove it entirely; scarring may also result.

With time, tattoos can fade or blur, especially if the artist has inserted pigment too deeply into the skin and the ink has migrated or the tattoo is in an area frequently exposed to sunlight. Using a sunscreen can help prolong the clarity and brightness of your tattoo.

Designs and colours

You can always choose from the samples that the tattoo studio offers, but a good studio will allow you to bring your own design as well. If you are designing your own artwork, or copying one from this book, draw it on paper and leave it somewhere visible so you see it frequently and can become accustomed to it. If you change your mind, at least you haven't committed to anything permanent.

For a completely unique design, consider a "custom-made" option where the artist collaborates with you. They may, however, charge by the hour for the design work in addition to the execution of the tattoo itself or may want a deposit to guarantee that you will go ahead with the tattoo once they've done the design work.

Another element to consider is colour and shading. Tribal, word-based or simple symbolic tattoo designs work well in a single colour, usually black. Bright colours are often used for complex designs over large areas, such as "sleeves" on the arms or large back decoration. Shading creates an added effect and is essential on some types of tattoos such as figures and portraiture. Even a simple black tattoo can be made more intricate with shading.

TIPS

- Take time before choosing a studio. Look at various establishments, the tattoo art ("flash") on their books and the tattoos the artists themselves have.

- Consider placement. Some areas are more painful to get a tattoo than others, such as bony areas like the wrist and the top of the foot. Also, areas such as your hands, neck or face can affect your future employment prospects.

- Ask how long the procedure will take. Small tattoos may only take 30 minutes to complete whereas large areas require several appointments, down-time between each appointment, and prolonged discomfort over several hours.

- Ensure the studio is scrupulously clean with disinfectant and sterilizing equipment evident.

- Ask to see the license of the artist/studio, which should be prominently displayed and dated.

- Do not consume aspirin or drink alcohol on the day: both can thin the blood.

- Rebook your appointment if you are feeling ill – you need to be in good health with your immune system operating at peak level.

- Eat or drink before you go to avoid feeling faint, and take water or an energy drink with you to keep hydrated and avoid a blood sugar drop.

- Ensure the artist is using a new needle – you need to see it removed from its packaging and inserted into the machine. Look for a dedicated disposal unit for used "sharps".

- Make sure that gloves are worn by the artist at all times, and changed with different processes, such as cleaning surfaces, dispensing inks and using the gun.

- Alert the artist if you suffer from any medical conditions, especially diabetes, heart or circulation problems that can preclude you from having a tattoo, or if you have a possible allergy to inks – red pigment is not tolerated well by some people.

AFTERCARE

Follow the recommendations of your tattoo artist; advice can vary from keeping a new tattoo covered for the first 2 hours to a lengthy 24 hours, but all advise against allowing prolonged contact with water for the first two weeks. This is not only to prevent exposure to bacteria but also to stop the tattoo ink from washing out or fading. Likewise, avoid the sun for at least three weeks. If a tattoo becomes infected or if the scab falls off too soon, then the ink may not "fix" in the skin and this will affect the final image.

After a few days, you may notice some peeling and possibly a little scabbing, as well as itching as the skin heals. Do not scratch or remove the scab but simply allow the skin to heal and follow the tips below.

- Avoid prolonged exposure to water for two to three weeks, including swimming in fresh or salt water, hot tubs or jacuzzis.

- Shower rather than bathe; it is fine to get your tattoo wet, just don't soak it.

- Avoid exposure to the sun for at least the first three weeks; thereafter always wear a sunscreen of 30 SPF or more over the tattoo to maintain the brightness of the colours and reduce blurring.

- Do not remove the scab if one forms over a new tattoo; allow it to fall off naturally.

- Keep the area clean and free of infection with lukewarm water and a mild antibacterial soap. Pat gently with a clean cloth to dry or allow to air-dry – do not rub.

- If it itches, do not scratch. Slap the area gently to remove the urge to itch.

- Apply an unscented, uncoloured antiseptic cream or ointment suitable for cuts and burns, or a proprietary cream specifically for tattoos, twice a day. Use just enough to keep the area moist to limit scabbing.

- Do not use a sauna, tanning salon or shave the area during the healing time.

Warning Signs

Infected tattoos are rare, but get immediate medical attention if you experience any of the following reactions.

- The area stays raised and itches longer than the first week.

- Bleeding continues after two days.

- The area feels hot to the touch.

- Swelling.

- Fever.

- Red streaks radiate from the site.

- Pus or cloudy fluid seeps from the wound.

- Bumps (granulomas) near the ink (this may indicate an allergic reaction).

ACKNOWLEDGEMENTS

The publishers would like to thank the following sources for their kind permission to reproduce the pictures in this book.

Key: t: top, b: bottom, l: left, r: right.

Dover Publications: 22tr, 30b, 40tl, 42, 43bl, 43br, 120tl, 122tr, 124t, 124b, 144r, 174t

Getty Images: 30, 45, 47, 58b, 122, 133

iStockphoto: 1, 3, 8 , 9, 10, 11, 12, 13, 14, 15, 17, 20, 21, 25, 32, 34t, 37, 40tr, 40b, 58tl, 58tr, 62, 68t, 76, 79, 81, 94, 96, 99, 120, 134r, 134tl, 134b, 135, 142tl, 142r, 143, 144l, 144bl, 152, 153, 158, 159b, 159tr, 161tl, 161tr, 161b, 162, 163, 166tl, 166b, 170, 171t, 171b, 174

Thinkstock: 8l, 8b, 16, 18, 19tl, 19bl, 19r, 22, 23, 26l, 26b, 33, 34br, 36, 43tl, 43tr, 60l, 60r, 68b, 77, 82, 83, 84, 85, 98, 145 tr, 145 tl, 145 bl, 145 br, 159 tl, 164, 172, 173

All other illustrations by Malcolm Willet and Patricia Moffet.

Every effort has been made to acknowledge correctly and contact the source and/or copyright holder of each picture and Carlton Books Limited apologizes for any unintentional errors or omissions which will be corrected in future editions of this book.